WEDDING
PHOTOGRAPHY
with Adobe® Photoshop®

RICK FERRO AND DEBORAH FERRO

AMHERST MEDIA, INC. ■ BUFFALO, NY

All photographs by Rick Ferro, except pages 11, 26, 33–66, 101–111 by Deborah Ferro.
On page 90, the top photograph was created by Rick Ferro with assistance from Michael Ballinger.
On page 96, the photograph was created by Rick Ferro with assistance from Sherri Ebert.

Published by:
Amherst Media, Inc.
P.O. Box 586
Buffalo, N.Y. 14226
Fax: 716-874-4508
www.AmherstMedia.com

Publisher: Craig Alesse
Senior Editor/Production Manager: Michelle Perkins
Assistant Editor: Barbara A. Lynch-Johnt

ISBN: 1-58428-095-6
Library of Congress Control Number: 2002112984

Printed in Korea.
10 9 8 7 6 5 4 3 2 1

Notice of Disclaimer: The information contained in this book is based on the author's experience and opinions. The author and publisher will not be held liable for the use or misuse of the information in this book.

TABLE OF CONTENTS

Rick Ferro's Acknowledgments

First, I want to thank the staff at Amherst Media, especially Craig Alesse for making real my goal of becoming an author, and of course Michelle Perkins, who really puts it all together for a book.

There are many more people who have played a big part in my professional career. Whether they are friends or family, I have so much respect for these folks:

For the last three years Tim Kelly has been helping me prepare for my masters degree, carefully helping me design and print my competition prints. Thank you ,Tim, for being such a professional.

To Curt Littlecott, truly a great, kind and loyal friend—and, needless to say, the best photojournalist in southern Florida.

Thank you to Janine Boylan from the Westin Grand Bohemian Hotel.

Without Monte Zucker and Big Daddy Don Blair I would not have had the success I have today.

And lastly, after 52 years of waiting for my own princess, my dream has come true. I dedicate this book to you, Deborah Lynn.

Deborah Ferro's Acknowledgments

I want to thank Craig Alesse for giving me the opportunity to co-author this book and to especially thank Michelle Perkins for her creative and technical input.

Appreciation goes to Scott Kelby, editor-in-chief of *Photoshop User* magazine, for offering an incredible resource for education and training through the National Association of Photoshop Professionals (NAPP).

Thank you to Bobbi Lane for encouraging me to make my passion for photography more than an expensive hobby.

A special thanks goes to: my mother, Peggy Broach, for being my inspiration and for always believing in me; to my children for their love and endless hours of modeling for me, and to our local guild (PPSNF) of photography friends for their tremendous support and friendship.

This book would not be complete without thanking my husband for his love, friendship, teaching and encouragement.

ABOUT THE AUTHORS

Rick Ferro

Rick Ferro, who holds a Master of Photography degree from PPA (Professional Photographers of America), is one of the nation's leading wedding photographers. In 1993, Walt Disney World approached Rick to create a wedding photography department. He became sen-

Photo by Susan Michal.

ior wedding photographer for Disney—and Walt Disney World became the world's most sought after wedding destination! As the department grew, it became an avenue for television weddings and Rick served as a photographer for ABC's *Weddings of a Lifetime* and for weddings on the highly successful *Regis & Kathy Lee Show*. Rick's first book, *Wedding Photography: Creative Techniques for Lighting and Posing*, was published by Amherst Media in 1999. He also offers a speaking program, which he delivers to standing-room-only crowds at regional and national photography conventions. As a member of the Professional Photographers of America (PPA), Rick has earned his certification degree. His images have also been honored with inclusion in the Loan Collection and Showcase Collection. From Wedding and Portrait Photographer's International (WPPI), Rick holds a Master of Accolades degree. He has also been honored by Kodak with the Kodak Master Gallery Award.

Deborah Ferro

After winning several awards as an active amateur photographer and photography student, Deborah opened her own studio in 1996. Specializing in portrait photography and digital artistry, her work attracted clients such as Pillsbury and Target. Now the wife and business partner of Rick Ferro in Signature Studios Inc., Deborah continues to stay on top of the latest trends in digital imaging and to teach her skills to photographers around the country in her seminar entitled "Practical Photoshop Techniques for Photographers." She is currently working toward her Masters degree from PPA.

▨ ABOUT THE CONTRIBUTORS

Tim Kelly is an award-winning photographer and the owner of a highly-awarded color lab. Since 1988, with the help of Eastman Kodak and and other corporate sponsors, Tim has been able to develop educational programs and to deliver them to professional portrait photographers worldwide. His studio/gallery in Lake Mary, FL, is devoted to fine art portraiture and handcrafted signature work.

Tim holds PPA's Photographic Craftsman and Master of Photography degrees. He has won numerous awards, including being named Florida's Portrait Photographer of the Year in 2001. He has earned numerous Kodak Awards of Excellence and Gallery Awards, and has had several images featured in the PPA Loan Collection.

Paul Brooks Rose is from Salt Lake City, UT, where he earned his BS in chemical engineering from the University of Utah. His

engineering background provided a natural progression into programming JavaScript, HTML, and other Internet programming languages, as well as to using the latest software for image processing and web page design.

As a guest speaker at a recent WPPI (Wedding and Portrait Photographers International) national convention in Las Vegas, NV, Paul spoke to photographers from around the globe on web site tools and Internet strategies. Along with his partner and wife, Jean Holland Rose, a marketing strategist, he is the force behind the Orlando Web Site Design Company of Orlando, FL. Look for their new book from Amherst Media, entitled *Web Site Design for Professional Photographers*. You can take a look at Paul's web site at www.orlandowebsitedesign.com

Photoshop Techniques

GETTING STARTED WITH PHOTOSHOP
AND UNDERSTANDING HOW IT CAN
WORK FOR YOU—WITH IMAGES
FROM TODAY, TOMORROW OR TEN
YEARS AGO.

1

GETTING STARTED

To go digital or not? That is the question! If you haven't stepped into the digital arena, it is only a matter of time before some component of the digital market will become useful to your business.

WHAT TO BUY

As you get started, decisions about what you need to buy (without going bankrupt) can be overwhelming. Information about the models and features of cameras, scanners, printers, software and tools for color management can make your head spin.

As you get started, the decisions about what you need to buy (without going bankrupt) can be overwhelming.

When advising you on where to get started, we suggest that your best investment is in Adobe® Photoshop®. It is an extremely useful tool for photographers, giving you much more creative control over your images. From basic photo retouching and creating collages like the one on the facing page, to marketing, preparing competition prints and creating clients' proofs and prints, Photoshop is worth the financial investment—and the time and patience you'll invest to become proficient.

COSTS

You should also keep in mind that you don't need to buy *everything* at once. For instance, many labs now offer scanning, file retrieval and digital printing services, so you may decide to wait to purchase a scanner and printer.

From basic photo retouching to creating collages, Photoshop is a valuable tool for photographers. For instructions on how to create collages in Photoshop, see page 60. Image by Deborah Ferro.

If your reason for going digital is to reduce your annual spending on film, you may want to reconsider! In addition to the financial investment and the learning curve involved, you must also take into account the enormous increase in production workflow that digital creates—work that was previously subcontracted out to a lab will become work that you will need to handle yourself.

DIGITAL PHOTOGRAPHY

When doing weddings, we offer both traditional film and digital photography. Rick captures images on medium format film with a Hasselblad and Deborah works in a photojournalistic style with a digital camera.

There are a variety of choices in digital cameras and backs—but bigger isn't *always* better. Unless you are planning to create poster-size prints, look for a camera that will produce a quality 8" x 10" print. On the occasions when you desire a print that is larger, there

are options for enlarging your digital file by resizing it. You can use software like Altamira's Genuine Fractals, and most professional labs have even more sophisticated software that can resize your file. Whatever your reasons for investing in digital, be realistic.

▦ WHAT YOU NEED TO KNOW

Working with Photoshop is exciting, but it can be challenging for the beginner. With patience and perseverance, your efforts will be rewarded by increased creative control over your images.

Before beginning the exercises in this book, you should have a basic working knowledge of Photoshop. If you are a beginner, we hope these images will inspire you to continue learning to use this valuable tool. We recommend that anyone who uses Photoshop become a member of NAPP (National Association of Photoshop Professionals). It is a wonderful educational resource— from its publication, to its web site, instructional videos and seminars. You can contact them at www.photoshopuser.com.

> With patience and perseverance, your efforts will be rewarded by increased creative control over your images.

▦ APPROACHES

There are several different ways to approach any one task in Photoshop. Even though some people are adamant about doing a certain task in only one way, we prefer to have you experiment. Whatever approach works best for you and decreases your workflow and cost is what we recommend.

For example, if you are doing black & white art pieces where you need high contrast, you may want to choose the Lab Color approach (page 27) for converting color images to black & white. However, if you are doing watercolor images where you are bringing back some of the color, you may want to use the Desaturate method (page 30) with your images.

Try different techniques for color adjustment, converting to black & white and retouching methods until you find the one that works best for you. Sometimes the approach you take will depend on the image. Whatever method you use, don't get frustrated or feel like you need to know or understand *everything* about Photoshop to use it. After all, you use electricity every day and probably can't explain *everything* about the way it works.

Most importantly, have *fun!*

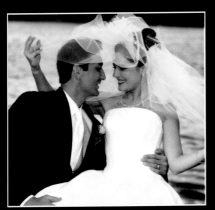

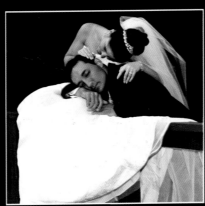

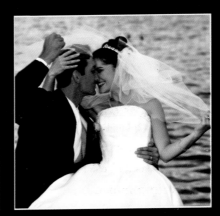

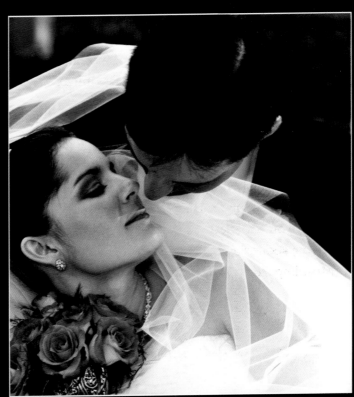

2

GENERAL PHOTOSHOP TECHNIQUES

Photoshop is a powerful tool that can replace your need for a retouching artist and even for black & white film—but it can *never* replace your need for excellence as a photographer.

You should always strive to get the best exposure possible to ensure the best results when enhancing in Photoshop. When scanning your film or prints, try to get the best possible scan, as this will save you a lot of time and effort when working with the image in Photoshop. Keep in mind, however, that all scans exhibit a shift in colors that can fool the eye when sitting in front of a monitor. Because of this, you should always color correct your image using Photoshop's Levels or Curves tools *before* doing any creative retouching.

You should always strive to get the best exposure possible to ensure the best results when enhancing in Photoshop.

Here are some basic steps to remember before retouching an image:

1. When opening an image in Photoshop, save your original scanned or acquired image and work on a *copy* of that image. Never work on your original! Should you want to change any adjustments, you will always have the original to go back to so you can start over or make a comparison.

2. Color correct your image using Photoshop's Levels, Curves or other color management tools. I prefer using Curves for

the majority of my work. If you decide to use Curves you will need to change Photoshop's default settings for Curves' CMYK settings that are in the Curves dialogue box. (This is the only time you will use CMYK, the rest of the time you will operate in RGB.) To change the settings, double click on one of the eyedroppers in the Curves dialogue box and then change the CMYK settings to the following:

To change the settings, double click on one of the eyedroppers in the curves dialogue box . . .

- Shadows: C=75, M=63, Y=62, K=100
- Highlights: C=5, M=3, Y=3, K=0
- Midtones: C=50, M=40, Y=40, K=10

This is a wonderful technique I learned from Scott Kelby, President of NAPP. You will only need to change these settings one time (unless you share your computer and someone else changes them or your computer crashes, then Photoshop reverts to its default settings again).

3. Always work in layers, naming your layers and saving often. Taking a little extra time to name a layer enables you to remember which layer had a certain effect that you or the client may want to change.

4. When retouching a portrait, remember that you want to *enhance* not *change* the way a client looks. Always seek the client's opinion to determine the amount of retouching that he or she prefers. Our responsibility as retouchers is to diminish any imperfections in a portrait without changing the person's characteristics.

Retouching should enhance not change the way the client looks. Photo by Deborah Ferro.

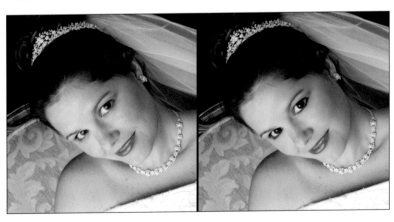

3

BASIC COLOR CORRECTION AND RETOUCHING

Before you do any kind of creative retouching, you will need to have your image color corrected. As previously noted, keep in mind that your eyes can fool you when looking at your monitor, and that all scanned images have a color cast that will need to be corrected. You always want to work on the best possible image to get quality results.

There are a variety of ways to color correct an image. Here is our preferred method for basic color correction and adjustment.

▪ COLOR CORRECTION USING CURVES

1. Open a copy of the original RGB color image you want to correct. The image that is seen below was scanned from a

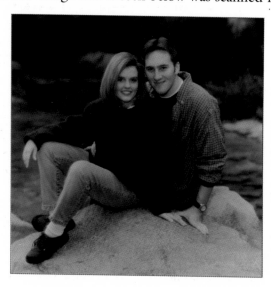

print. Like all scanned images, it needs a little work to look its best. In this case, the scanned image is too dark and lacks contrast. It also has a bit of a green cast.

2. Drag your Background image to the New Layer icon at the bottom of the Layers palette to make a copy (the New Layer icon is circled in the screen shot below). This will enable you to quickly reference the "before" and "after" versions of your correction.

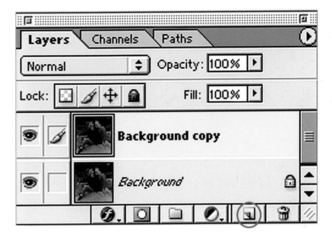

3. To color correct using Curves, go to Image>Adjustments> Curves (or use the keyboard shortcut: Ctrl+M for PC or Cmd+M for Mac) and a Curves dialogue box will come up. Remember that you should have already changed the CMYK settings as discussed on page 15.

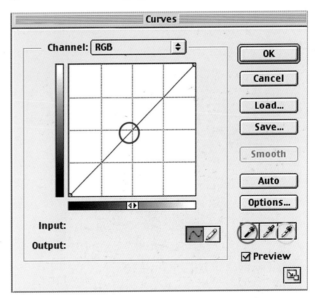

4. Click your mouse on the shadow eyedropper (the black eye-dropper circled in red in the screen shot above). Then select

the darkest area in your image that has detail and click on it. For this image, we clicked on the groom's black shirt.

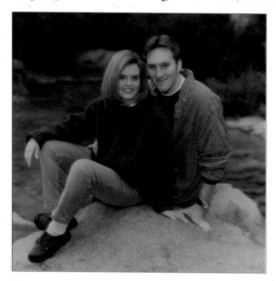

5. Next, click on the highlight eyedropper (the white eyedropper circled in yellow in the screen shot on page 17). Then click on the area that is lightest with detail. If the area doesn't produce the results you want (or results in the highlights being blown out), try clicking on a different area.

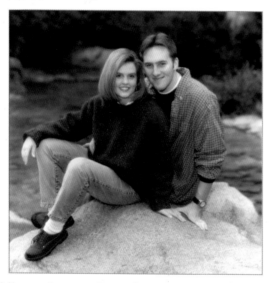

6. The middle eyedropper is used on an area in the image that is closest to 18% gray. This is sometimes difficult to approximate and not always necessary to correct in an image. We seldom use this eyedropper when color correcting.

7. Click on the center point of the curve (indicated by the blue circle in the screen shot on page 17) and move it slightly up or down until you get the depth of color you want. In this

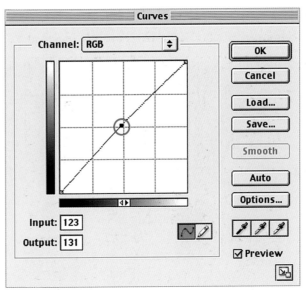

example, the center point of the curve was pulled up slightly to brighten the midtones.

8. If there is any remaining color cast, select the channel you think needs to be adjusted from the Channel pull-down menu at the top of the Curves dialogue box. For example, if there seems to be a blue cast, select the blue channel. Here, the green cast was pretty much taken care of by carefully setting the black and white points. If it had not been, we'd have selected the green channel and pulled down slightly on the center of the curve (as seen in the screen shot to the left below). If the image seems too cool, consider accessing the red channel and pulling up slightly on the center of the curve (as seen in the screen shot to the right below). These adjust-

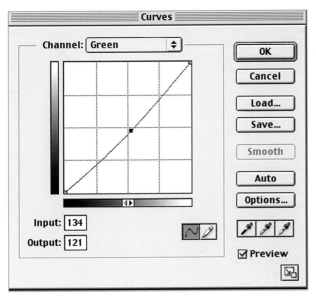 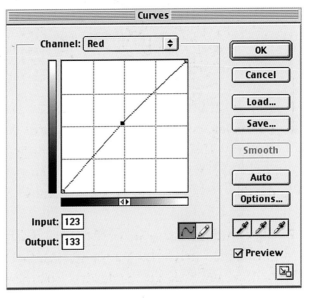

ments should generally be quite small. When you are happy
with the results, click OK to finish your correction.

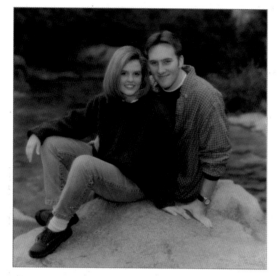
Portrait before color correction.

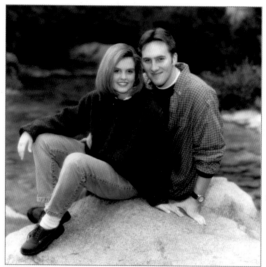
Portrait after color correction.

9. At this point you can save your image as a PSD file. This will
maintain the layers, in case you should want to further adjust
the image.

Photoshop is not just for color image retouching. Whether
importing an original black & white image or scanning a black &
white image for restoration, it is important to know how to achieve
the best results from Grayscale images. The same procedure used to
correct a color image can also be used to optimize the tonal range of
your black & white photos. An example of this procedure is shown
on the next page.

For this example, the image was converted directly from RGB to Grayscale. This is not the recommended way to convert a color image to black & white (see pages 26–33) because it produces a very flat, dull look. Assuming that your original image was Grayscale to start, however, these steps will show you how much you can improve the photograph with a few seconds of work. This is helpful to keep in mind when working on problem exposures or faded black & white prints—most of which can be dramatically enhanced in terms of their contrast and tonal range.

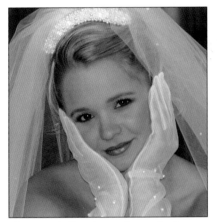

Converted directly to Grayscale from a color photo, this image needs a bit of correction to look its best in black & white.

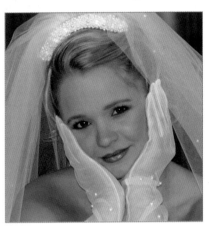

In the Curves dialogue box, the black eyedropper was selected. Clicking on the darkest area in the center of her eye set that spot as the black point and adjusted all of the tones in the image accordingly.

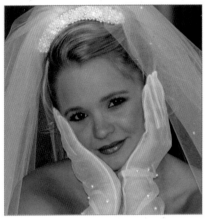

Clicking with the black eyedropper on a dark area of the background set that point as the black point. However, the adjustment made the midtones too dark.

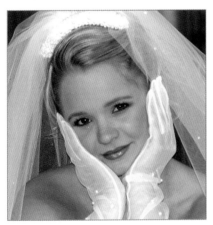

Next, the white eyedropper was selected from the Curves dialogue box and clicked on a pearl in the bride's headpiece. This set the white point, but set it a bit too high—some detail is lost on the pearls.

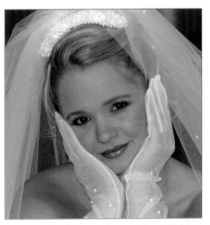

After a little experimentation clicking with the white eyedropper, a better spot was found—one that accommodated the lightest tones while preserving detail.

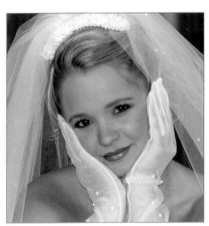

Finally, the Curves were adjusted slightly to brighten the midtones a bit.

Any of the problems that you would traditionally have given to a professional retoucher to have corrected can now be dealt with digitally—and you can do them yourself. A few common issues are discussed in this section. Take your time and practice each technique. Like traditional retouching, these skills are quite subjective and require some experience to master and make look seamless. Additional techniques will be covered in the following chapters.

Blemishes, Wrinkles and Dust Spots
Small blemishes are most commonly thought of as occurring on the skin, but can also include scuffs on walls or the floor, particles of dust on a scanner bed that get scanned into an image—even multiple catchlights. The methods used to retouch each of these small problems are the same.

1. Open a copy of the image that needs to be corrected, then select the Zoom tool from the tool bar and use it to zoom in closely on the area that needs to be corrected.

2. If you are using Photoshop 7.0 or later, select the Healing Brush tool. In the Options bar at the top of the screen, set the Mode to Normal, and the Source to Sampled. (For earlier versions of Photoshop, see the next page.)

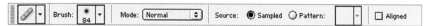

Then, select a brush that is soft and slightly larger than the size of the blemish you wish to conceal. Press Opt/Alt and click on a nearby area with the same tonality as the blemished area should have. This creates a sample of that area. Release the Opt/Alt key and click on the blemish. If the effect

doesn't seem to blend well, go to Edit>Undo and try sampling a slightly different area. If you can't get the look you want with the Healing Brush tool, read on for tips on using the Clone tool and give that a try.

If you are using a pre-7.0 version of Photoshop or aren't getting the look you want with the Healing Brush tool, you can perform much the same job using the Clone tool (also called the Rubber Stamp).

Unlike the Healing Brush tool, the Clone tool does not automatically blend your sampled tonality in with the areas over which you "stamp" it. Therefore, it is extremely important to sample from an area with the precise tonality you want to see covering the blemished area. This can take a little trial and error, so be prepared to hit Edit>Undo a few times until you get it just right.

When working with the Clone tool, try setting the opacity quite low (say, 20–30%). Then, if clicking once doesn't provide sufficient coverage, click again (click a third time if needed). By setting the opacity low and clicking on only as much "concealer" as required, you can best preserve the natural surface texture found in the area that you are retouching. This is an important factor in creating an effect that looks natural.

Shine

Women are especially aware of how unflattering shiny skin can look, yet it can be hard to eliminate—especially on stressful or hot days. Guys can also benefit from the removal of spots of shininess that often crop up on the forehead, nose or cheeks.

1. Open a copy of the image you wish to retouch. Here, the shine is very soft, but the same techniques can be used for harsher shiny spots.

2. The Clone tool works well for this job because it allows you to set the opacity as you like—for this application, about 10% should be fine. Select a soft brush that is a bit larger than the area of shine you want to cover. Set the Mode to Normal.

3. Press Opt/Alt and click on an evenly-toned area with a tonality very close to what you'd like to see replace the shine. Move your cursor over the shiny area and click until the shine is reduced—but not so much that the highlight is eliminated.

Catchlights

Catchlights make the eyes sparkle—without them, your subject may look dull and lifeless. To add (or enhance) a catchlight, use the following procedure.

1. Open a copy of the image to be retouched. If you don't remember the position of the main light, evaluate the shadows on the subject's face to determine where it would have been. (The catchlight, as a reflection on the eye of the main light, should be placed appropriately to look realistic.)

2. Select the Airbrush tool and choose a brush that is the size of the catchlight you want to create. Set the Hardness of the brush to about 50% so the catchlight will blend slightly and not look like an isolated dot on the eye. Set the Foreground color to white, position your cursor where you want the catchlight to appear and click your mouse once.

Note: It is usually considered a technical error for more than one catchlight to appear in the eyes. To remove extra catchlights, follow the steps on pages 22–23.

4

COLOR TO BLACK & WHITE

When you are first learning Photoshop, converting a color image to black & white appears to be a very simple task; however, there are several different ways to approach black & white conversions. We will

Left: Lab Color conversion. Right: Desaturate with color. Photograph by Deborah Ferro.

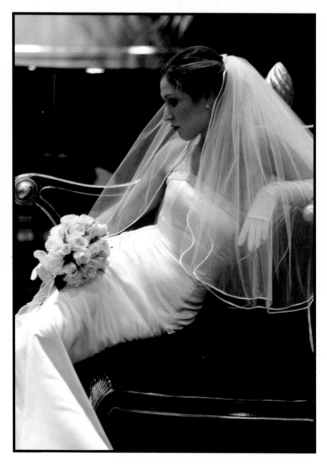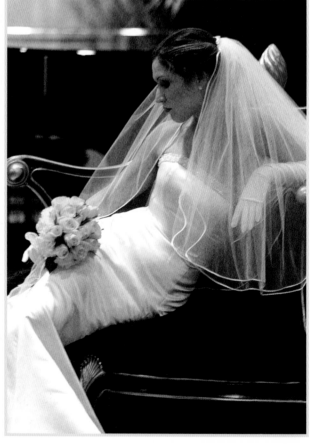

show you the two methods that we use the most: Lab color conversion and the Desaturate method. The Lab Color conversion method works best when you want a crisp black & white print with high contrast. It seems to render deeper blacks and very little grain. Our second choice, which is very useful when bringing back some of the color of the original image, is to Desaturate the image for the black & white conversion; however, it renders the image flatter and somewhat more grainy. On the facing page are examples of the two different approaches using images from a digital camera.

▢ LAB COLOR CONVERSION

1. Open an RGB image that has been color corrected and retouched. If it is in layers, flatten the image and go to File>Save As. This will allow you to create a working copy of your image so that you will not lose your original color image, which is saved in layers.

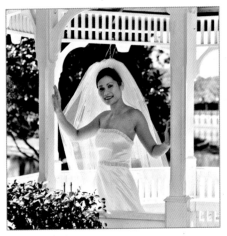

2. For this process, you will have to work on the Background because the Lab color mode does not allow you to work in layers—it can only work on a flattened image. That is why you must save a copy of your corrected, retouched color image for further use later.

3. Go to Image>Mode>Lab Color. (Don't worry—you will not see any immediate results).

4. Click on the Channels folder-tab at the top of the Layers palette (or go to Window>Channels).

5. Click on the Lightness channel with your mouse. Your image will now change to appear black & white.

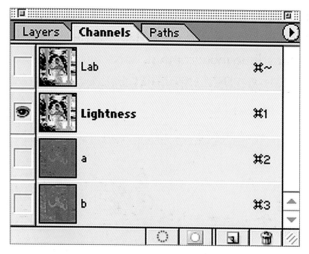

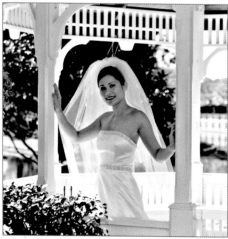

6. Drag the "a" channel into the trash can at the bottom right corner of the Layers palette (this "a" channel creates an unneeded alpha channel). When you are done, your Channels palette should look like the one below.

7. Click back on the Layers folder-tab in the Layers palette (or go to Window>Layers).

8. Go to Image>Mode>Grayscale.

9. Then go to Image>Mode>RGB (you always want to print in RGB mode).

10. At this point, we usually go to Image>Adjustments>Levels (Ctrl+L for PC or Cmd+L for Mac) to move the sliders and adjust for a little more contrast.

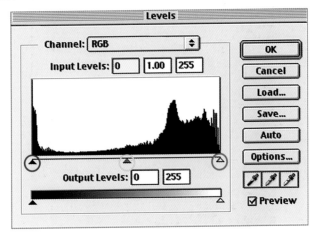

Moving the highlight slider (here circled in red) and/or the shadow slider (here circled in blue) in toward the midpoint slider (here circled in yellow) will increase the contrast. To lighten the midtones, slide the midtone slider to the left; to darken them, slide it to the right.

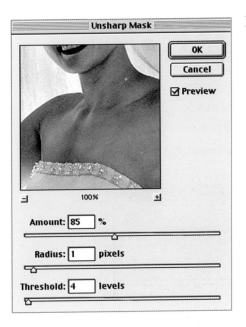

11. The last step is to sharpen the image by applying the Unsharp Mask filter. To do this, go to Filter>Sharpen> Unsharp Mask. My preference for sharpening is: Amount=85, Radius=1, Threshold=4. I sometimes repeat the filter, if necessary. Avoid oversharpening the image, as this creates a very unnatural look.

1. Open an RGB image that has been color corrected and retouched.

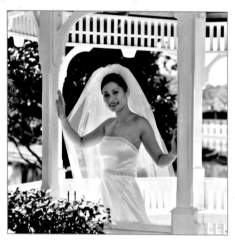

2. Drag the Background image to the New Layer icon at the bottom of the Layers palette.

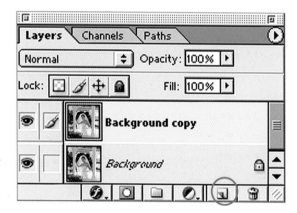

3. Go to File>Save As and save the image as a PSD file (this creates a working file separate from your original).

4. Working on your Background copy, go to Image>Adjustments>Desaturate.

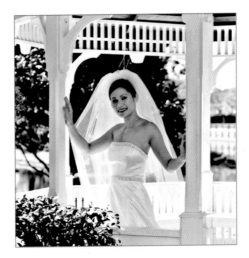

5. At this point, you can use the Levels to adjust the Background copy (now in black & white) for a little more contrast, if it is needed.

6. With the Zoom tool, enlarge your image to between 100–200% to see detail.

7. Click on the Eraser tool in the tool bar. Select a small to medium-sized soft brush and set it to 100% opacity.

8. Erase any black & white area of the image and you will restore its color. (What you are doing is actually erasing the Background copy layer and revealing the underlying original Background image.

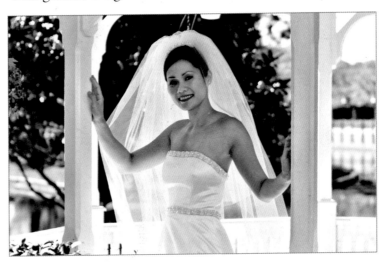

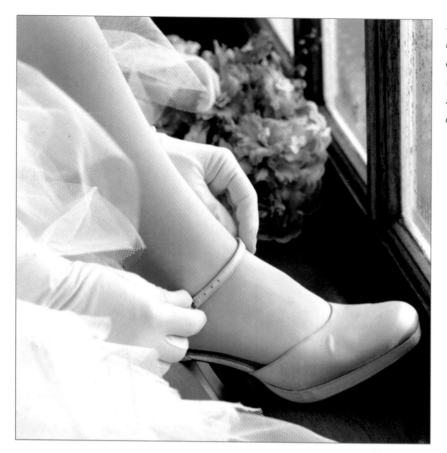

Erasing the desaturated Background copy layer with the Eraser tool set to 100% opacity reveals all of the underlying layer (top). Setting the Eraser to an opacity of 50% creates a softer, more "handcolored" effect (bottom).

9. If you would like to soften the color to give it a more "hand-colored" look, then reduce the opacity of your Eraser in the Eraser's option bar. An example of the difference this can make is seen on the facing page.

Below is an example of an image that we converted to black & white using the desaturation method. We then restored some of the color from the Background. We also added grain to this picture by going to Filter>Noise>Add Noise.

Image by Deborah Ferro.

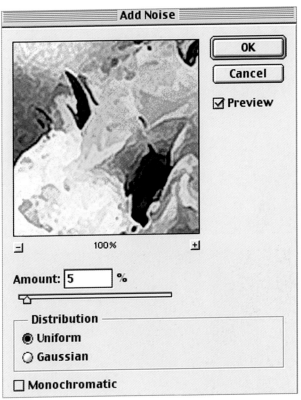

After applying the grain effect, we added an edge to the photograph with Extensis Photoframe software, but you can create your own custom edges in Photoshop (see pages 67–73).

5

SEPIA TONE AND WATERCOLOR EFFECTS

We were asked by the Grand Bohemian Hotel in Orlando, Florida, to do a photo shoot with models for images to be used by the hotel. From those images, we created a sample album for our studio that

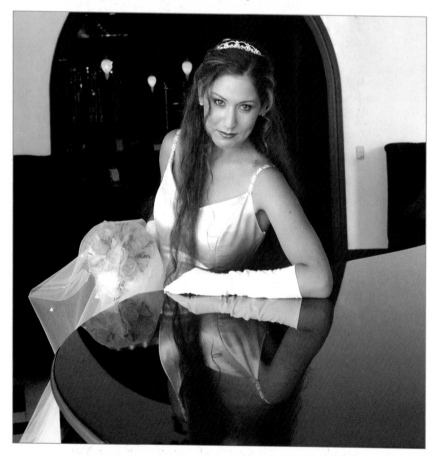

We have had tremendous success with special albums using entirely sepia and watercolor images. They are all done with archival materials—a concern of contemporary brides. Image by Deborah Ferro.

was all in sepia tones and watercolor effects created using Photoshop with images captured on a digital camera. These were displayed in a Jorgensen Tapestry album from Albums, Inc., giving it a very old-fashioned feel. We also included poems and scriptures about love.

Because the images were printed using archival inks, papers, adhesives and pens, the entire album was archival—which is a concern of brides today. It has been a tremendous hit at our bridal shows, giving the bride something different. We have offered it as a "Diary of the Bride's Wedding Day" or as a "Love Story," telling the story of how the couple fell in love.

The following images are from this album. Using these examples, you will learn how we like to do sepia tone and watercolor effects.

▢ SEPIA TONE

1. Open a color-corrected RGB image that has been retouched as needed. (The image shown below has not yet been finalized. The clips holding the model's dress were removed with the Clone tool. We cropped the image, then proceeded with the following steps.)

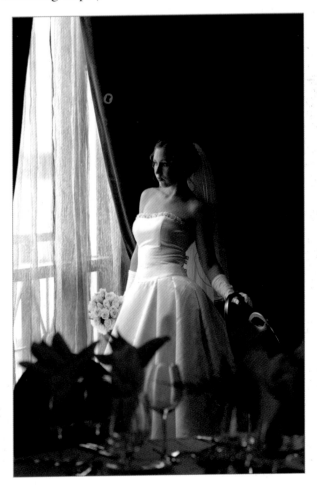

Image by Deborah Ferro.

2. Drag the Background to the New Layer icon at the bottom of the Layers palette.

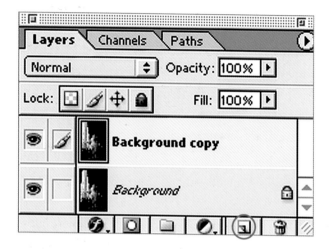

3. Go to File>Save As and save as a PSD file.

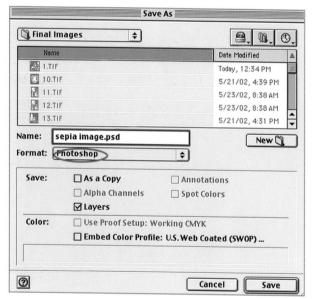

4. Go to Image>Adjustments>Desaturate.

5. Go to Image>Adjustments>Hue & Saturation (Ctrl+U for PC, or Cmd+U for Mac).

6. In the Hue & Saturation dialogue box, make sure the Colorize box is checked (when you activate this box, the Saturation setting will move to its default of 25).

7. Slide the Hue slider to the left to 27 or until you get the sepia tone you prefer. You can also adjust the saturation slider if you like.

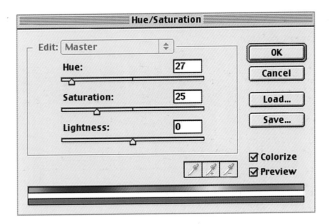

8. Click OK and flatten the image. Add an Unsharp Mask.

When creating sepia-toned images for a complete album or for several prints going to the same client, you should make sure that all of your prints have exactly the same color sepia. For this reason, it is helpful to remember the number you set the Hue slider to.

The final sepia image can be seen on the following page.

Keep in mind, the same procedure used to create a sepia-toned look can also be employed to add other creative color casts to your images.

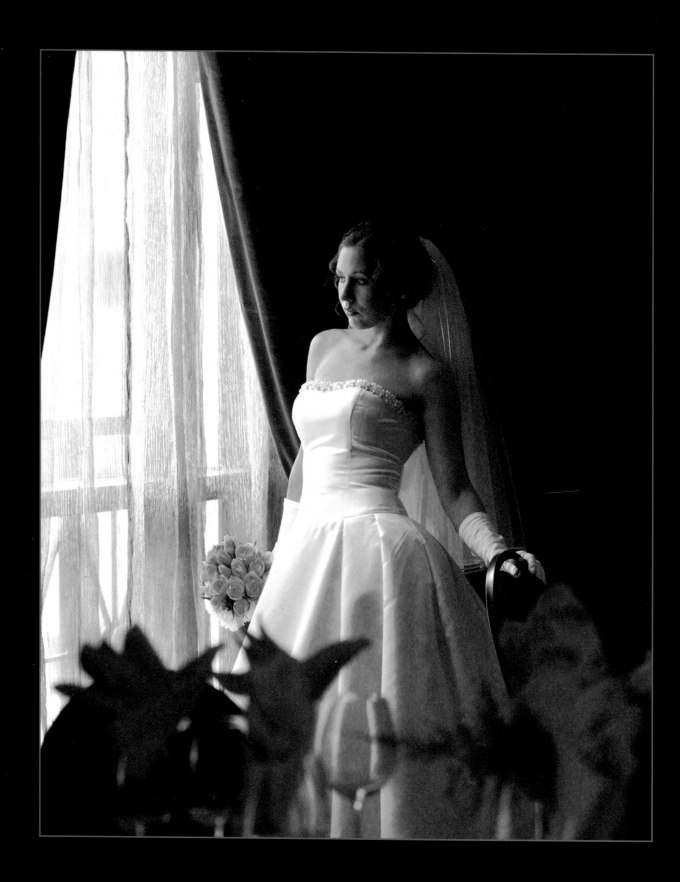

Deborah has a background as a watercolorist, and from this perspective feels that Photoshop doesn't render a true watercolor print. If you want to achieve a true watercolor "painterly" look, we suggest you try Corel's Painter® software. With Painter, you would be hard pressed to tell whether the image was painted with a traditional artist's brush or with a digital brush (a stylus on a graphic tablet). However, Photoshop does offer a wonderful variety of artistic filters that will require little time.

To achieve the watercolor look seen in the sample image on page 42, we used the Dry Brush filter. This seems to render a better look than the Watercolor filter in Photoshop.

1. Open a color-corrected RGB image that has been retouched as needed.

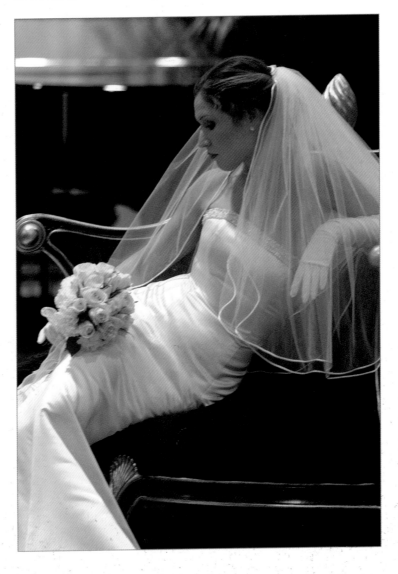

2. Drag the Background to the New Layer icon at the bottom of the Layers palette.

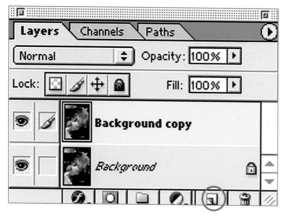

3. Go to File>Save As and save as a PSD file.

4. Go to Filter>Artistic>Dry Brush. In a window at the top of the dialogue box that appears, you can actively preview the effect of the filter. Under the preview window are three sliders that control brush size, brush detail and texture. As you increase the Brush Size, you'll notice that fine detail in your image starts to disappear. As you increase the Brush Detail, the strokes will seem finer, preserving more detail. As you

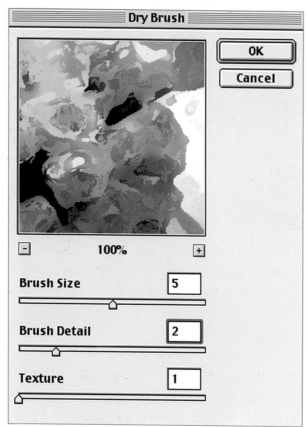

increase the Texture setting, the contrast between highlight and shadow areas will become sharper.

When you are satisfied with the results, hit OK to apply the filter.

5. The effect of this filter can be rather unflattering on faces. Therefore, after applying the filter to a portrait, make sure that you erase around the face (revealing the unaltered layer underneath). This will ensure that detail will not be lost and that the face will not look distorted. To better blend the effect, you can set the opacity of the Eraser tool to less than 100%.

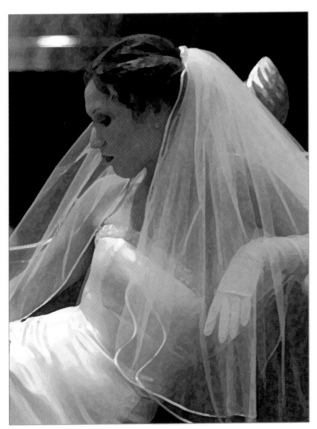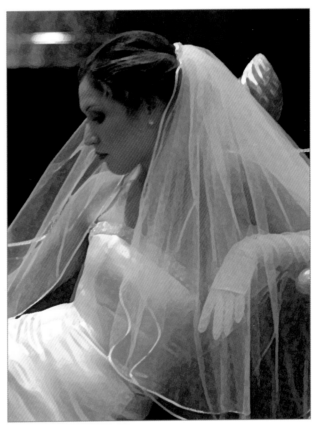

The Dry Brush filter can create unflattering effects on the face (left), but it can be softened by erasing the overlying layer to reveal the unaltered layer beneath it (right).

After the watercolor effect is achieved, I often like to add a frame using Extensis Photoframe software.

By experimenting with filters, you will quickly learn which ones you prefer to use on your images. When you are experimenting with filters, make sure to try them one at a time using the same image.

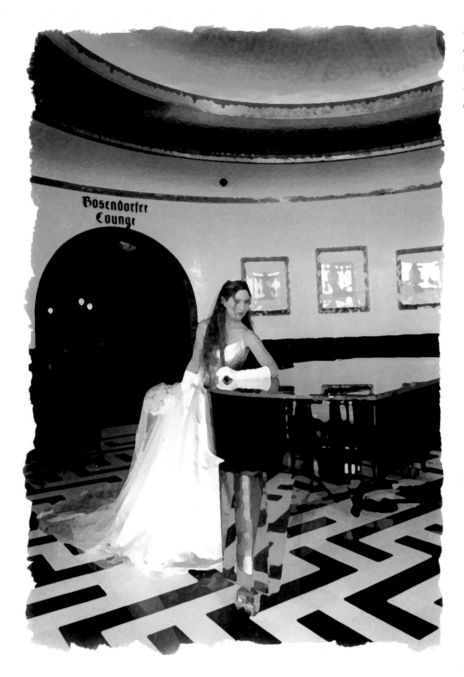

By experimenting with filters, you will quickly learn which ones you prefer to use on your images. Here, the Dry Brush filter was used to create a water-colored look. Image by Deborah Ferro.

Each filter can look totally different when applied to a different image.

If you are printing your own work on an inkjet printer you can print an image without any applied filters onto watercolor paper and still achieve an artistic look. We use Epson watercolor paper on our Epson printer and deckle the edges of the paper by hand.

We use Corel's Painter for watercolor portraiture and Photoshop's Dry Brush filter for our watercolor cards.

6

ADVANCED RETOUCHING TECHNIQUES

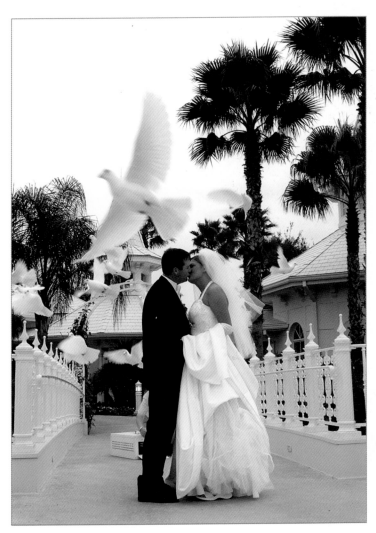

When photographing weddings, you are constantly dealing with new surroundings and wedding guests that come into the frame just as you take the photograph. You don't always have the time that you do in the studio to set up or control your background.

The following examples are of images where something in the frame kept the image from being the best it could be. Thanks to Photoshop, we now have the ability to turn average images into exceptional ones!

◫ REMOVING UNWANTED OBJECTS

In this image, the man releasing the doves was visible in the frame (as seen in the image to the left). By removing the man and the lamp post behind him, we created an image in which your eyes focus on the couple and the doves.

1. Open your color-corrected RGB image (left).

2. Drag your Background to the New Layer icon at the bottom of the Layers palette.

3. Go to File>Save As and save as a PSD file.

4. Working on your Background copy, zoom in to 100–200%.

5. With the Lasso tool set to feather 2 pixels, make a selection around the outside of the object that you want removed. In this case, lasso around the man bending down, the lamp post and on the edge of the groom's side.

6. With the Clone tool, press Alt/Opt and click on an area outside of your selection that you want to replace the unwanted

object with. In this example, I cloned an area of the sidewalk and an area of grass to fill in over the areas of the cage, arm and lamp post that I selected.

7. After replacing the unwanted areas I removed my selection by going to Select>Deselect.

You can also apply the Clone tool *without* making a selection; however, using a selection is helpful because it protects the rest of the image from accidentally being destroyed or cloned over while you are covering the problem area.

Feathering the selection as you make it (as noted in step 5) will help the newly-cloned areas to blend more smoothly with the areas around them. You can also feather the selection at any time by going to Select>Feather and entering the desired value.

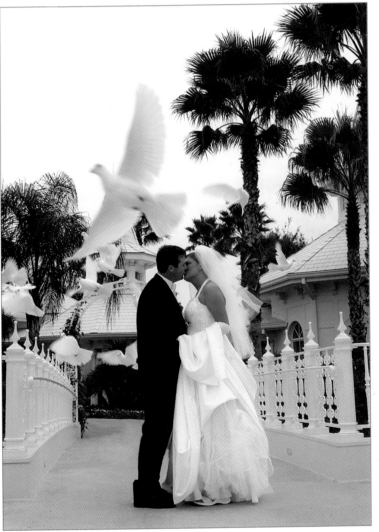

By removing the man and the lamp post behind him, we created an image in which your eyes focus on the couple and the doves. Image by Deborah Ferro.

In the next example, the background column was crooked and the image needed to be cropped. The image also lacked impact, so with a few adjustments in Photoshop the image had a much better presentation.

1. Open a color-corrected RGB image that has been retouched.

2. Drag the Background to the New Layer icon at the bottom of the Layers palette.

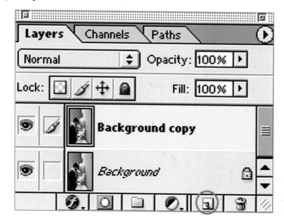

3. Go to File>Save As and save as a PSD file.

4. Choose the Marquee tool, and set its tolerance at zero pixels (in the options bar).

Make a rectangular selection above the bride's head straight up and to the left (the area with the crooked column). Select the Magic Wand, then press Opt/Alt and click on the part of the bride's veil that is within the Marquee's selection. This will remove it from the selection.

5. With the Clone tool, press Opt/Alt to sample a matching area for cloning from the dark area of the wall.

6. With the Clone tool, fix the part of the column that is not straight by replacing it with the area cloned from the dark wall.

7. Remove your selection by going to Select>Deselect.

We continued on with this image by converting it to black & white as previously described on pages 26–33.

We then added grain for effect and last but not least, topped it off by cropping the image and adding a frame using Photoframe by Extensis. (For ideas for creating your own frames in Photoshop, see pages 67–73.)

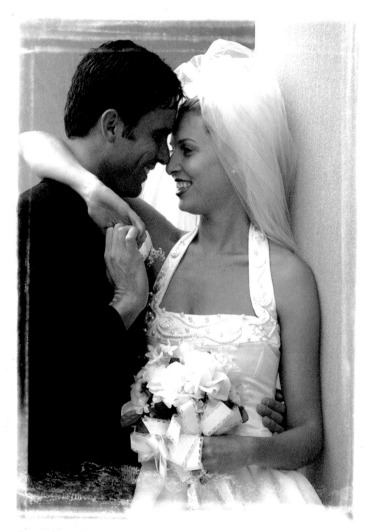

Image by Deborah Ferro.

When Deborah is doing photojournalism with the her digital camera, she is often photographing around Rick—taking sometimes 250–500 images at a wedding. Because her images are digital and can be deleted, she has the opportunity to be more spontaneous than Rick, and capture that unexpected image when the subjects are unaware.

Because Rick is directly in front of the bride and groom to get his shot, Deborah is normally working from a different perspective. In this beach scene, the horizon line wasn't ideal, but by using Photoshop we were able to create the desired result—one that we couldn't have captured on film.

In the first image (below, left), we liked the spontaneity of the pose, but in the second image (below, right), we liked the large amount of sky. We also wanted to correct the horizon line. Prior to combining these images, you will need to color correct them side by side so that their tonal values will match.

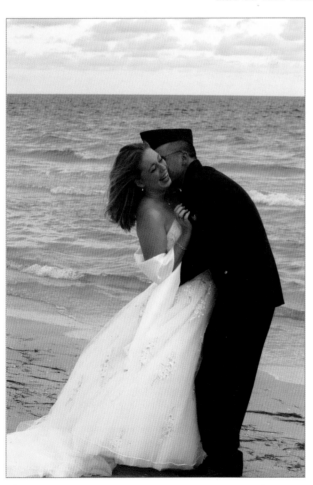 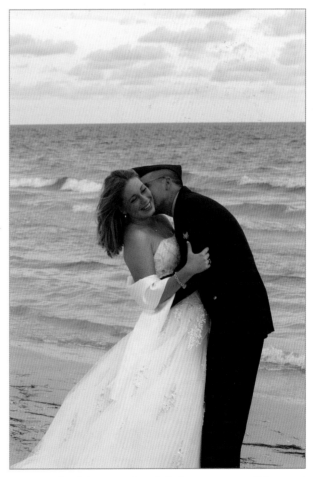

In the image on the left, we liked the spontaneity of the pose. In the image on the right, we preferred the large amount of sky—and the horizon line was also better. Images by Deborah Ferro.

1. Using the Curves and/or Levels tools, color correct both of the images side by side until they match.

2. Go to Image>Image Size and make sure that both images are at the correct resolution and cropped to the same size, and that the bride and groom are close to the same size in each frame.

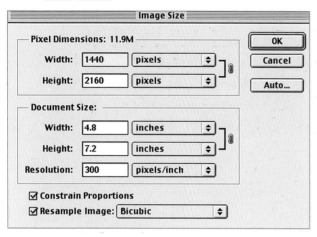 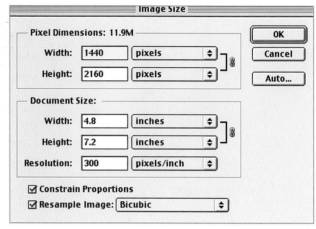

Image size data for frame 1 *Image size data for frame 2*

3. Working on the second image, select the sky completely across the entire image with the Rectangular Marquee tool.

4. Move your selection to a new layer by hitting Ctrl+J for PC or Cmd+J for Mac. This will automatically jump your selection to a new layer.

5. With the Move tool, drag your selected new layer from the second image over to the first (the one with the preferred pose).

6. Drag the selected sky layer into the first image again, so that you have two layers of sky. (Don't worry about covering up the top of the bride and groom—we will fix that.)

7. Close the second image (the one from which you borrowed the sky).

8. Using the Move tool, drag one of the sky layers down until the horizon is in the desired position in relation to the couple's bodies.

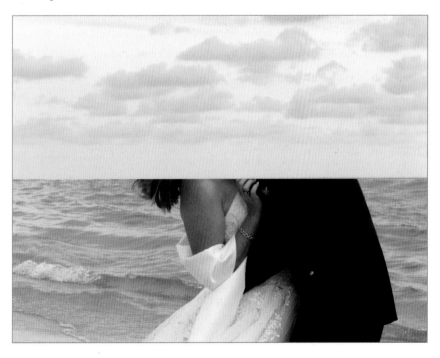

9. In the Layers palette, click on the arrow at the top right corner and select Merge Down, to combine your two layers of sky into one layer.

10. In the Layers palette, reduce the opacity of your sky using the Opacity setting. Lower the opacity until you are able to see the bride and groom clearly.

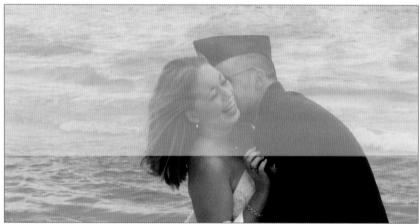

11. Zoom in to view the image at 100–200% enlargement.

12. Select the Eraser tool and choose a soft brush. Set the Eraser's opacity to 100%, then erase the part of the sky that

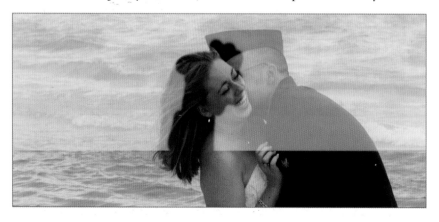

covers the bride and groom, making sure to keep the edges of your work very precise. You will probably need to use a combination of different brush sizes to do this.

13. In the Layers palette, set the opacity back to 100%.

14. In the Layers palette, select Merge Down from the pull-down menu at the top right corner. This will merge the sky layer onto the Background.

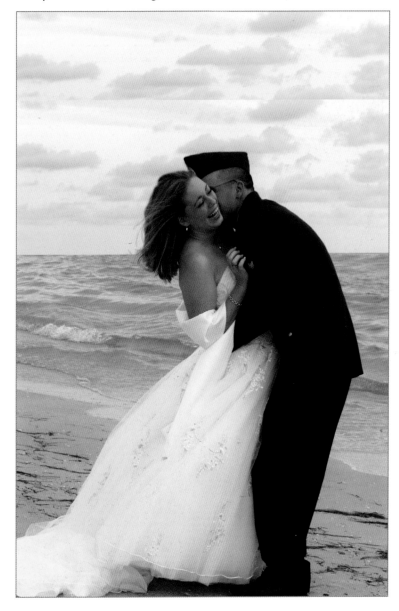

15. Drag the Background to the New Layer icon at the bottom of the Layers palette.

16. Working on the Background Copy layer (which you may wish to rename "Retouch"), clean up any imperfections in the sky or clouds (previous page, bottom right). You can do this by using the Clone tool to copy an area of clouds or sky, then apply it over the area you wish to conceal. The Healing Brush tool may also be useful in this process. Choose soft brushes and blend carefully to make the effect look natural.

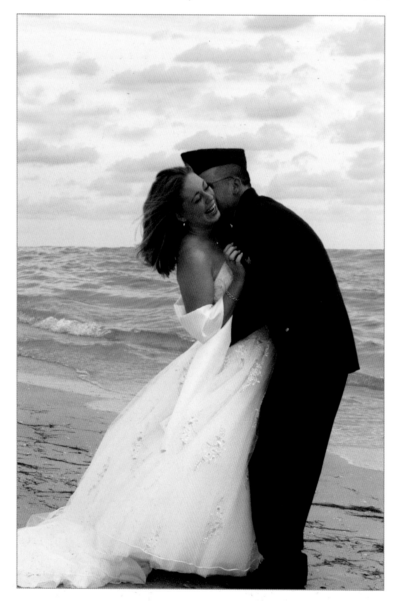

18. As needed, retouch the bride and groom.

19. Flatten the image (Layer>Flatten Image) and save.

We also wanted to show that the bride and groom were moving, dancing and having fun. To emphasize this, we added the appearance of movement by applying the Motion Blur filter. Here are the steps:

1. Duplicate the Background layer by dragging it onto the New Layer icon at the bottom of the Layers palette.

2. Click on the Background layer copy to activate it, then go to Filters>Blur>Motion Blur and adjust blur until you get the desired effect of motion.

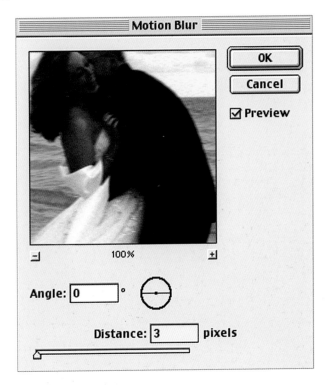

3. With the Eraser tool set at 100% opacity, erase the Motion Blur on the bride and groom's faces.

Applying the Motion Blur filter to the entire image (left) eliminates sharpness in the faces as well. By applying the filter to a duplicate layer, you can use the Eraser tool to remove the blurred image data over the faces, revealing the sharp ones on the underlying layer (right).

 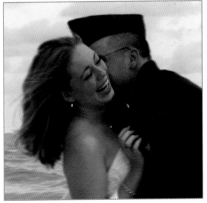

4. Flatten the image (Layer>Flatten Image).

5. Apply an Unsharp Mask by going to Filter>Sharpen>Unsharp Mask.

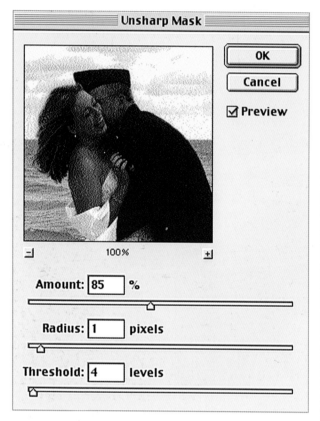

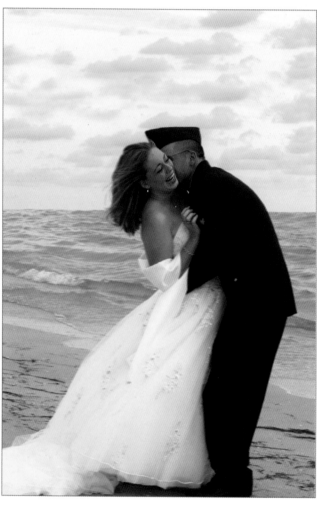

Applying the Unsharp Mask filter (above) restores a bit of the sharpness while retaining the sense of motion (right).

To add a vignette effect, we used a vignette frame by Extensis—but you can achieve the same effect in Photoshop.

1. Choose the Elliptical Marquee tool, and use it to select the area that will *not* be affected by the vignette (namely, the bride and groom).

Begin by selecting the unvignetted area including the subjects (left), then inversing the selection to the area around the subjects where the vignette will be applied (right).

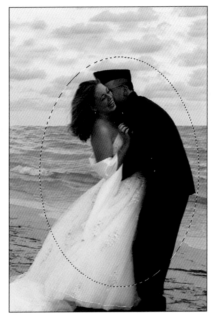 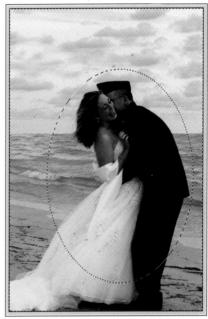

2. Next, inverse this selection by going to Select>Inverse. This will select the area that was *not* in your original selection (this area, the part of the image surrounding the bride and groom, is the area where the vignette will be applied).

3. Create a new layer by clicking on the New Layer icon at the bottom of the Layers palette.

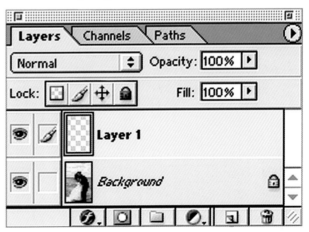

4. Clicking on the Foreground Color icon at the bottom of the tool bar activates the Color Picker. From there, select a color for your vignette. For this image, the vignette color is white. (You can also pick white by clicking the icon under the Foreground Color in the tool bar. This will revert the color settings to black in the Foreground, white in the Background. Then, click the icon above the Background Color icon to reverse the Foreground and Background Colors.)

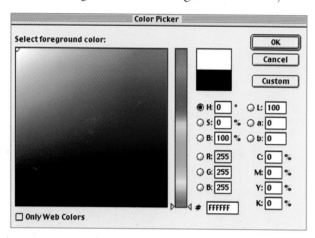

5. With the new layer active, feather the selection (Select> Feather). The larger the setting you choose, the softer the edges of your vignette will appear.

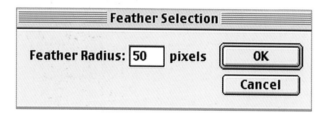

6. Fill the feathered selection with the Foreground Color (Edit>Fill).

You can also fill the vignette with the Foreground Color by selecting the Paintbucket tool and clicking on the image within the selected area.

7. Flatten (Layer>Flatten Image) and save the photograph.

The final composited, motion-blurred and vignetted image is shown below. The original is also shown for comparison.

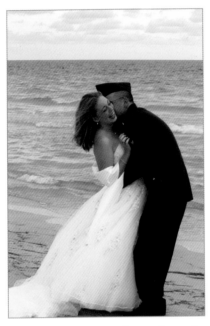

The original image is shown above. The composited, blurred and vignetted final image is shown to the right. Images by Deborah Ferro.

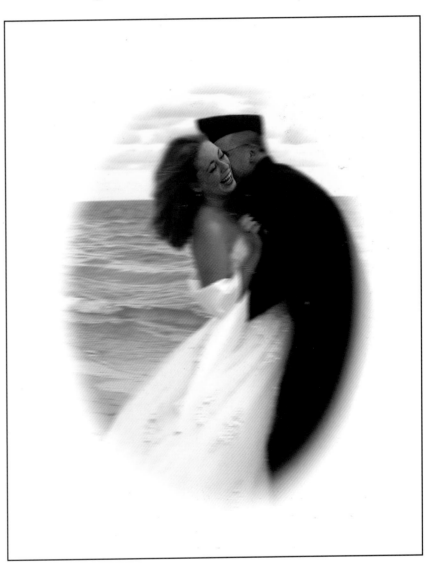

7

COLLAGES

Collages can be used for marketing purposes (see pages 101–13) and for client images and album pages. For the photographer who competes at the local, state or national level, collages created in Photoshop for competition are becoming more and more the standard. Whether a single image with a mat and stroke is created or combined images are used, the possibilities are limitless.

In the example below, titled *A Toast to Forever,* three 5" x 5" images were combined for a slender collage.

 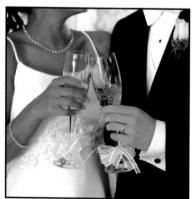 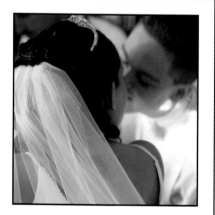

For the example we will review step-by-step, three images were used. One was digitally handcolored and used as the background, while the others were converted to black & white and added to the collage. You can follow the steps below to create a similar collage using your own images.

Images by Deborah Ferro.

Step A

1. To create the background image for your collage, begin by sizing the background image. It should be at the same size as your desired final print.

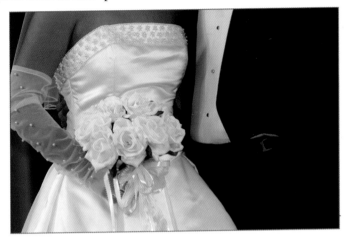

2. Make a copy of the Background layer by dragging it onto the New Layer icon at the bottom of the Layers palette.

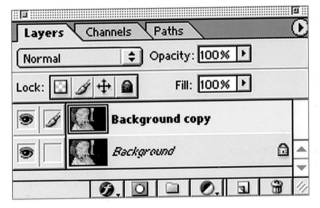

3. Desaturate the image by going to Image>Adjustments> Desaturate.

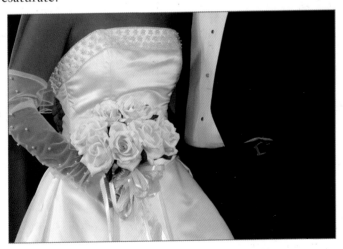

4. By adjusting the setting at the top of the Layers palette, reduce the opacity of your saturation to bring back a little bit of the color.

The result is softer than the original color image.

5. To add color to create a "handcolored" effect, select the Brush tool and set it to the color mode (in the Options bar). Set the opacity to 25% and set the Foreground Color as you

like (click on the Foreground Color to bring up the Color Picker, select a color from the Swatches palette, or adjust the sliders in the Color palette). Then, color the petals of the bouquet.

Step B

1. Open the additional images to add to the background.

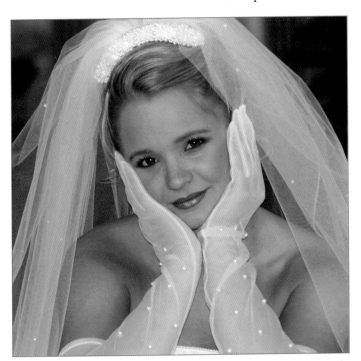

2. Crop the images to the desired size to fit on the background, keeping the resolution the same as the background.

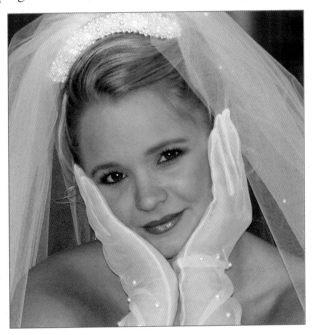

3. Covert the images to black & white using the Lab Color method or the Desaturate method (see pages 26–33).

4. If needed, use the Levels or Curves tool to increase the contrast in each image.

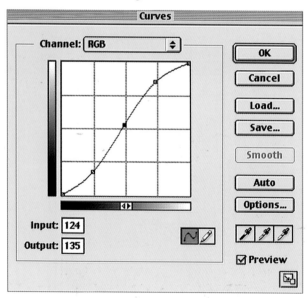

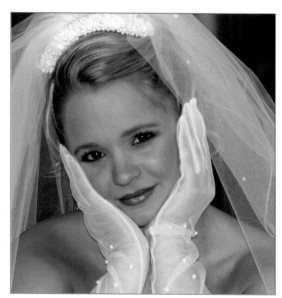

5. Flatten each image (Layer>Flatten Image).

6. Next, create a line (called a stroke) around each image. To do this, select the entire image by going to Select>All (or Ctrl+A for PC, Cmd+A for Mac). Then go to Edit>Stroke. The larger the number on the width setting, the wider the line around the photo will be. The stroke color will be set automatically

to your Foreground Color. If you want to change it, click on the color swatch for the color. This will bring up the Color Picker. Since the selection line to which the stroke will be applied runs around the very outside edge of the photo, select Inside for the location of the stroke, so you will be able to see its full width.

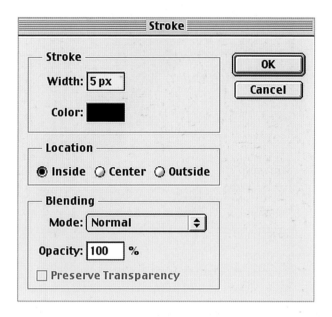

7. Choose the Move tool and drag each image into the background image file. You should now have three layers—one for the background, one for the bride's portrait and one for the groom's portrait.

Step C

1. Position the images as you like.

2. Flatten the collage.

3. Sharpen the entire collage with the Unsharp Mask filter.

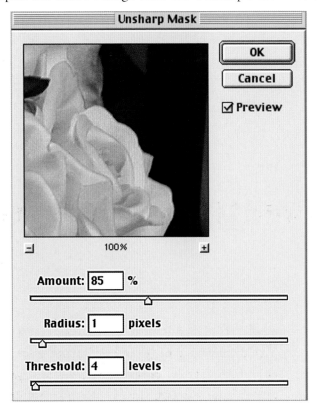

4. Save the finished image as a TIF file.

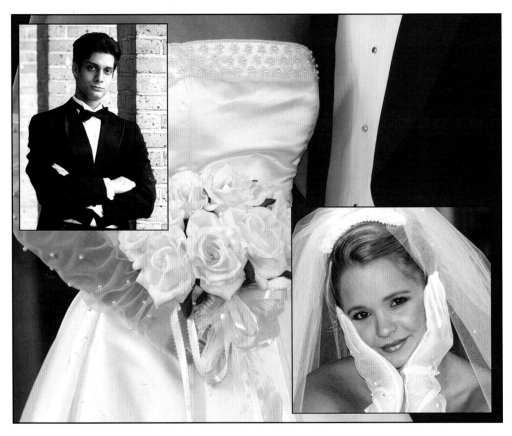

8

CREATIVE EDGE EFFECTS

As you have probably noticed, many of our images employ artistic edge effects. While these can be created using any of the available software products designed specifically for the purpose of creating borders on photographs, they can also be made within Photoshop itself. With a knowledge of filters, selections and a few other basic tools, your imagination is the only limit. If you use Photoshop 7, you can also use Actions to create borders—several ready-to-use Actions are included for you to use on any image.

With a knowledge of filters, selections and a few other basic tools, your imagination is the only limit.

▨ ACTIONS FOR CREATIVE EDGE EFFECTS

An Action is basically a set of pre-recorded manipulations that you can "play back" to achieve a desired effect on your image. To use an Action, open an image in the RGB mode and go to the Actions

palette (Window>Actions). Click on an Action from the list to highlight it, then press the play button (the triangular button at the bottom of the palette). If you want to see how an Action does what it does, click the triangle next to the name of the Action and each step will be revealed.

The default set of Actions includes a couple of options, but you can access additional frames by clicking on the black triangle at the top right of the Actions palette. At the bottom of the list is a set of actions called "Frames.atn"—just click on the name to load these frames into your Actions palette.

The examples below show a few of Photoshop's frames created using the built-in Actions.

Photo Corners frame

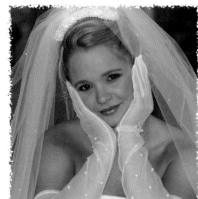

Spatter frame

Brushed Aluminum frame

Ripple frame

Cutout Frame

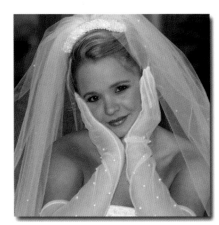

Drop Shadow frame

To create textured edges, we'll use the filters in Photoshop via a simple process that employs alpha channel selections.

1. Open an RGB image.

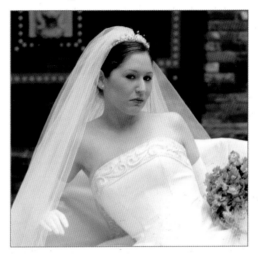

2. Set white as the Background Color in the tool bar.

3. Increase the canvas size (not image size) of your image (Image>Canvas Size) by one inch in each direction to give you access to the edges of the frame so that you can create uneven edge effects.

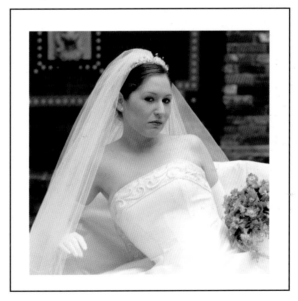

4. Using the Rectangular Marquee tool, select all of your photograph. Invert the selection (Select>Inverse) so that only the white area around the image is selected.

5. Go to Select>Save Selection to create a new alpha channel.

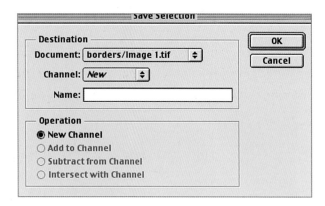

6. Once you have saved your selection, go to the Channels palette and click on the new channel. This will bring up the channel in your main window. The selected area will be white, and the unselected area will be black.

7. The selection should still be active on the white area (indicated by the dancing dotted line around it). Go to Select> Modify>Expand. Enter whatever value you like—20 to 30 pixels is a good starting point, but you'll probably want to experiment.

The active selection on the new channel now includes both white and black portions of the channel.

8. Now you can get creative. For this example, we'll create the look of torn edges. With the selection still active, go to Filter>Sketch>Torn Edges. Adjust the settings as you like, and hit OK.

10. Return to the Layers palette and click on the layer containing your image to activate it.

11. Go to Select>Load Selection and choose the channel you created in step 5.

12. With the new selection active, go to Edit>Clear to clear the selected area and create the look of torn edges. Deactivate the selection to see the results.

To the right is the image with the finished border. Above is an enlarged view of the border effect.

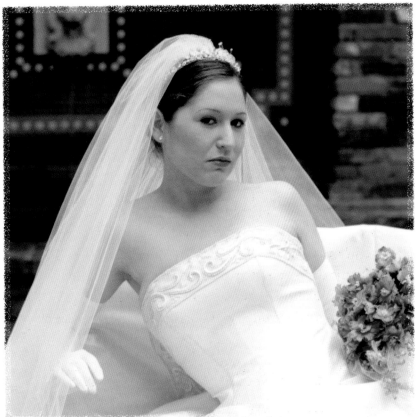

There are limitless variations that can be applied using this method—try applying more than one filter in step 8, or perhaps two different filters. You may want to blur the selection or add grain to it.

In this section, you will learn how to use your scanner to create and apply borders.

1. To begin, find a scannable sample that you want to use to create your border.

2. Scan it at the highest resolution and size at which you want to use your image (you can always reduce its size). Here, a photo with a rough black border (printed in a traditional black & white darkroom) was used. To preserve the irregular inner edge of the border, we'll set it up so that it can be placed over another photo.

3. Using the Marquee and Magic Wand tools, select the photograph within the frame and fill the image area with 100% white (Edit>Fill).

4. Next, open the photograph to which you will apply the border (it should be at the same resolution as the border and roughly the same size).

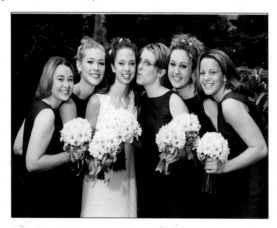

5. Set your Background Color to white, then increase your canvas size (Image>Canvas Size) by about two inches in each direction. This creates a one-inch white border around the photo to allow for the irregular edges of the frame.

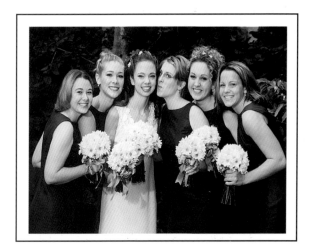

6. Drag the layer containing the border into the open image file with the photograph. In the Layers palette, set the mode of the new layer with the border on it to Multiply, allowing the image to show through the white areas of the border.

7. If necessary, adjust the border to fit the image by going to Image>Transform>Distort. Use your mouse to click and drag the box-shaped handles one by one until the border fits the image as you want it to.

8. Flatten and save the photograph.

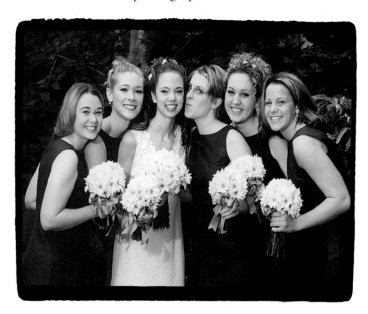

SECTION TWO

Photographing a Wedding

IN THIS SECTION IMAGES ARE
PRESENTED AND DISCUSSED BY
RICK FERRO. DIGITAL TECH-
NIQUES FOR ENHANCING
THESE IMAGES ARE PRESENTED
BY DEBORAH FERRO.

Engagement Portraits

One of the most enjoyable jobs I have is getting together with couples before their wedding—there's so much excitement in the air! They are full of anticipation and wondering how you will depict their love story and create something they will treasure forever.

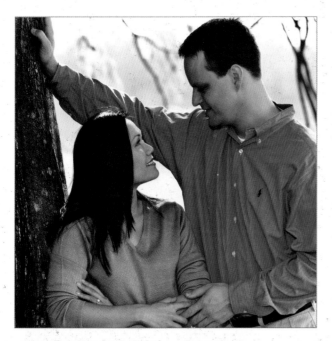

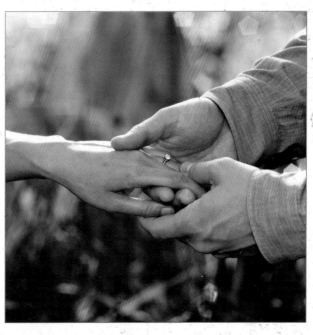

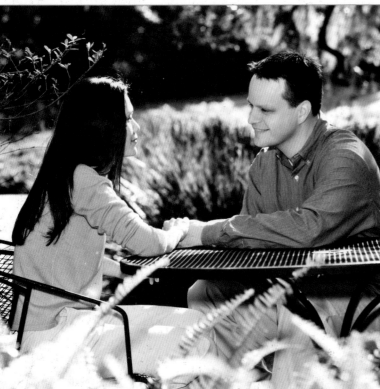

When I first started in wedding photography, I learned quickly that you have to give a lot to earn a lot. I made next to nothing the first few years—but I knew I was building a future for myself. I remember going to Monte Zucker's seminars or a WPPI (Wedding and Portrait Photographers International) convention and seeing the images that were displayed by the pros—and that's what I wanted. I failed a million times, but with a lot of trying it finally happened. Developing this confidence and level of comfort is an important factor in the success of a photographer.

Just as comfort is important for you, the photographer, it makes a world of difference when your subjects feel comfortable, too. That's

one of the reasons I think an engagement session is very helpful—it gives me a chance to get closer to a couple. They can see how I operate and know what to expect on the day of the wedding. Grooms especially are likely to be a little uncomfortable in front of the camera, so this session can help you to loosen him up and take the edge off his nervousness. The more relaxed he feels, the more you can achieve in terms of his posing. Additionally, the session gives us an opportunity to discuss the styles they like and what they want in their

 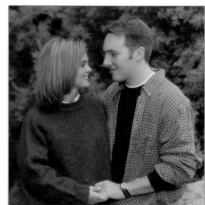

wedding images—and the more information you have on this, the better prepared you'll be to capture images they will love.

I usually schedule an engagement portrait about two or three months before the wedding. For environmental portraits, I prefer to set aside at least two hours. The most critical aspect is the clothes the couple chooses—these can make or break the portrait! You'll need to remind them that everyone has their favorite clothes, but those clothes aren't always the best for portraits. You might get them thinking about appropriate clothing choices by suggesting they might want to match the room in which they plan to hang the portrait. Alternately, suggest neutral colors and pastels in classic styles (and avoid checks or plaids!).

PHOTOSHOP TECHNIQUE

On pages 57–59, we covered how to apply a white vignette to an image. For lower key images, a darker vignette is typically more appropriate. It can be applied following the same basic procedure—and keep in mind that you can adapt this as you like to incorporate effects with filters, different colors, softer or harder edges on the vignette, etc.

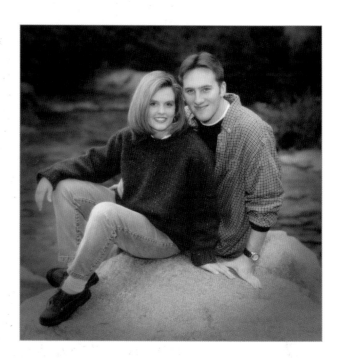

1. Open an RGB image and create a new layer. Work on this new layer.
2. Use the Elliptical Marquee to select an area around the subjects. (You can also use the Lasso tool if you prefer to draw an irregular selection.)
3. Go to Select>Inverse.
4. Feather the selection as much as you like.
5. Go to Edit>Fill and select black as the fill color.
6. Reduce the opacity of the layer as you like

Pre-Wedding Bridal Portraits

A pre-wedding session is an excellent idea for brides who want a very polished look in the their individual portraits—or who just want to avoid having their portraits made on a day when there is already so much to do. Like the engagement session, it also allows the bride to become more familiar with your style. A pre-wedding session also gives you added time to style the dress perfectly, do makeup and hair touch-ups as needed, etc.

A pre-wedding session is an excellent idea for brides who want a very polished look in the their individual portraits.

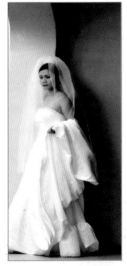

Normally, the bride brings flowers to the session. This bride didn't, so we worked without them. In the image shown directly below, you see a rather unusual pose for me. I don't normally like the body positioned square to the camera. In this case, though, the bride's head at an angle and her arms spread side to side worked with the lines of the gazebo for a successful portrait.

I fell in love with the lines and contrast in the scene used for the images to the left—all I needed to do was place the bride appropriately. As I looked over to her while we were setting up the shot, I

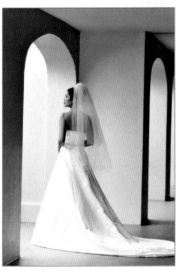

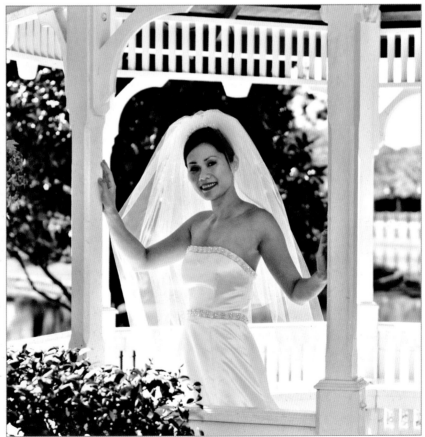

noticed she had not yet dropped the train of her gown (top left photo, previous page). I quickly grabbed the camera and took the shot. As it turned out, it was one of her favorite unposed shots in the session!

With the classic light and pose seen in the photo to the right, who needs flowers? Just be sure not to let the bride's hands dangle—instead, arrange them to create balance and a graceful appearance. A Quantum flash was tucked in behind the column in front of the bride and set at f-5.6. The light from the flash provides flattering illumination on the bride's face and skims across her gown, revealing its texture.

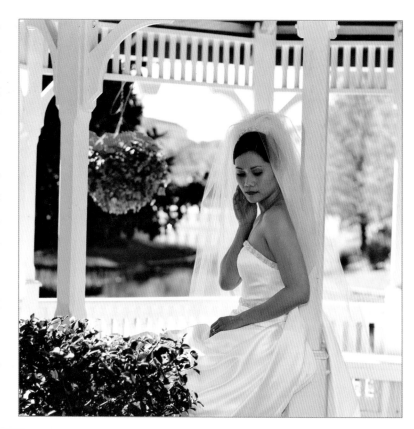

PHOTOSHOP TECHNIQUE

On pages 46–48, we looked at one method for straightening tilted verticals. Depending on the image, there are other methods you can also employ.

If the verticals are only tilted (all leaning one direction), you can crop the photo to correct them. To do this, select the Crop tool, then click and drag from the top left corner to the bottom right corner of your image. Then, grab the handle at any corner of the bounding box and use it to rotate the box When the vertical sides of the bounding box are parallel with your verticals, look at the corners. If any of these lay outside of the image area, reposition them inside the frame. Then, double click inside the box to apply the crop.

If the verticals converge, duplicate the Background layer. Then, click and drag guides across the image to the areas where verticals appear. These provide a perfectly vertical reference against which you can evaluate your changes. Then go to Edit>Transform>Distort. When the bounding box appears, grab a corner handle, then click and drag out or in to begin correcting the verticals. You may need to make small adjust-

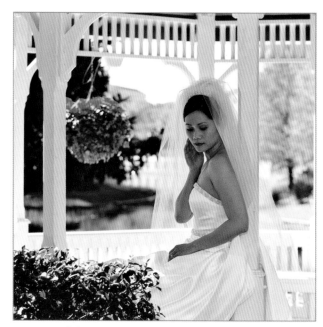

ments to all four corners. This is best used for mildly crooked verticals, since it can result in subject distortion as well (you can check this against your duplicate Background layer).

In the image above, both the cropping and distortion methods were used to straighten the verticals.

In the Dressing Room

The dressing room is where it all begins. If you have opportunity to photograph the bride in her home before the wedding, you capture a place that will always remind her of her beginnings—the room she slept in, the dolls she played with, etc. This is a great opportunity to make images that will bring that all back to her and, for that reason, will always be very special.

When I photograph a bride at home, I get there at least two hours early so I can scout out the location and get a good idea of the best places to work. I also request a list of special places and ask that certain family members and friends be there: parents, grandparents, godparents, bridesmaids and pets—yes, pets. Want to see big sales? Get a picture of the bride with her dog!

I get there at least two hours early so I can scout out the location and get a good idea of the best places to work.

In the room where the bride is dressing, pay attention to little things like garters, jewelry and shoes (guys may not realize this, but brides spend a lot on their shoes!). The most important thing to photograph is the wedding dress. I like to use multiple lenses and get as

In this image by Deborah Ferro, the bride proudly displays the treasured family jewelry that has been passed down to her.

many angles as possible. I also photograph the gown in both color and black & white.

For these shots, I use window light as much as possible. Where the windows don't provide enough light, I use a little flash bounced off the ceiling. Award-winning photographer Don Blair quite rightly calls this "garlic light"—because a little goes a long way!

As far as photographing the bride getting ready, I'm now able to leave that to my wife. If possible, having a female assistant available for this work is a good idea, as the bride and bridesmaids will probably feel more comfortable being themselves around another woman.

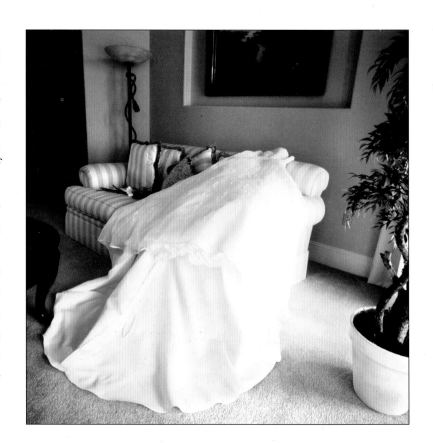

PHOTOSHOP TECHNIQUE

On page 32, we looked at a "handcolored" variation on the image seen on page 81. This is just one method for adding colors to an image, and only works with images that were created in color. If you are starting off with a black & white image (or want to change/enhance the colors in your original color image) try employing color layers.

1. Open an RGB image and create a new layer. In the Layers palette, set the Mode of the new layer to Color. Work on this new layer.
2. Select the Brush tool and a brush.
3. Set the Foreground Color to the color you want to "paint" onto your image, and start painting.

If you're not too confident about your painting skills, don't worry! You can select the Eraser tool and quickly remove any color that ends up where you don't want it. As you color different parts of the image, you may want to add additional layers in the color mode. You may also want to adjust the opacity of these layers, depending on the effect you want. If you

aren't quite happy with the colors, you can also adjust the Curves or the Levels of the color layer.

The example shown below reflects a composite of four possible colorizations of an image—from vivid to subtle.

Wedding Customs

Every culture and religious tradition has its own customs and key events in a wedding ceremony. As the photographer, it's important that you understand the type of ceremony you will be photographing—otherwise you might miss events that the couple and their family consider very important.

Keep in mind, the wedding is a religious ceremony, not just a social event. You should respect this by refraining from the use of flash photography during the ceremony itself. Fortunately, with the new high speed films, this is becoming less of a challenge. However, you should still practice working with ambient light so you know that you can produce excellent results in the varying conditions presented.

Knowing you will be working in such low-light situations, look for a camera with a mirror lockup feature. This helps prevent camera movement caused when the mirror swings out of the way during an exposure. You should also invest in a good, sturdy tripod with a head that can be easily adjusted in different directions. For long exposures, this is really a necessity.

The crowning is probably the most important moment of the Greek Orthodox ceremony. For this shot, Fuji 800 film is a lifesaver!

For example, Greek Orthodox weddings usually involve a long ceremony during which those in attendance stand most of the time. As a result, you are likely to see movement in your ambient light images. It is not uncommon for the minister to ask you to stay back from the altar area where the wedding is being performed. I happened to be lucky at this wedding—not only was I allowed to get close, but I was even allowed onto the stage area!

A key image to get is the couple with their godparents. The godparents sit up front in the church as witnesses and are in just about every formal grouping.

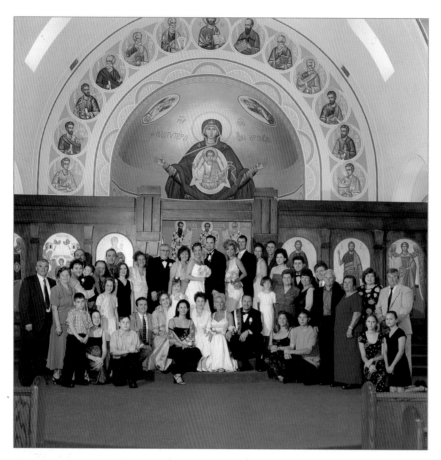

When it comes to formals, Greek Orthodox weddings are like most other weddings—except you should expect to have some big groups! With groups as big as the one shown in the photo above, the key is to start small, and add a few people at a time. Arrange the people according to their relationship to the couple, and make sure that no one is blocking anyone else. (Keep in mind, you can also sell this kind of image as a panoramic!)

PHOTOSHOP TECHNIQUE

With Photoshop, it's easy to present your images in any format you like—square, round, panoramic, etc. If you pose a large group portrait as a long, horizontal grouping, like the one above, you'll have a good candidate for creating an appealing panoramic. Just select the Cropping tool, then click and drag over the image. (To crop to a specific size, enter the desired height and width in the Options palette at the top of the screen.) To create round or oval image shapes, select the Elliptical Marquee tool, then click and drag

over the image (this can be a little hard to get just right, so be patient). With the area selected, go to Select>Inverse and then hit Edit>Clear or fill the selection with white.

Introduction of Bride and Groom

Once the ceremony is complete, stay on your toes—the bride and groom may make a dash for the back of the church! You have to be prepared for these shots, since you only have one chance to catch them. I set my Hasselblad's lens to f-8 and focus to fifteen feet, then work as if with a point & shoot camera. Don't

Stay on your toes—the bride and groom may make a dash for the back of the church!

even consider stopping them for a posed shot. Instead, work fast and capture images of a moment so full of excitement that, half the time, the couple doesn't even remember what happened.

There is a lot of hugging and crying at this point in the day, so stay a bit behind and record the moments as they happen. I've actually

been at weddings where the photographer blocked the couple coming back up the aisle—it looked terrible! Get your shots, and get out of the way.

If there is a receiving line, your strategy should be much the same—blend into the crowd and pick your shots. Wait for intimate moments and capture them. I tend to shoot a lot of black & white during this part of the wedding.

PHOTOSHOP TECHNIQUE

Using vignettes and digital "mats" creatively can yield nice effects that make a plain background look more interesting or make a busy one seem less distracting. To create the effect seen to the right, follow these steps:

1. Open an RGB image and duplicate the Background layer. Work on this duplicate layer.
2. Use the Elliptical Marquee to select an area around the bride and groom.
3. Add a stroke to this selection (Edit>Stroke). Apply the stroke to the inside of the selection. Here a five-point stroke was added in white.
4. Inverse the selection (Select>Inverse).
5. Go to Image>Adjustments>Brightness/Contrast. Reduce both settings to −68.
6. Apply the Dry Brush filter (Filter>Artistic>Dry Brush) using whatever settings you like.
7. Apply the Noise filter (Filter>Noise>Add Noise) using whatever settings you like.

The Bride and Bridesmaids

As photojournalism becomes an increasingly popular style of photography, I myself am trying to get away from the "stand and smile"

I manage to shoot just about everything that comes in front of my camera—and enjoy shooting weddings more because of it.

shot. My clients still come to me because they want my traditional images, but I also manage to shoot just about everything that comes in front of my camera—and I enjoy shooting weddings much more because of it.

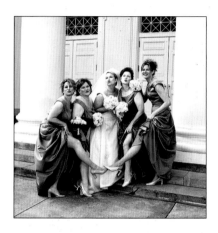

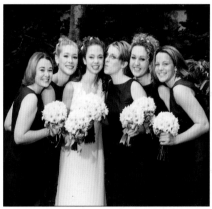

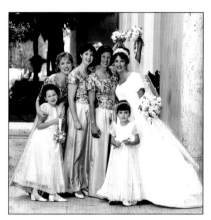

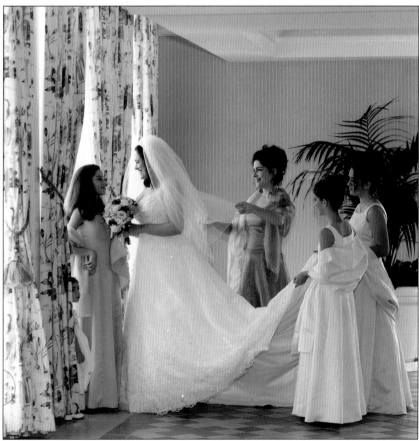

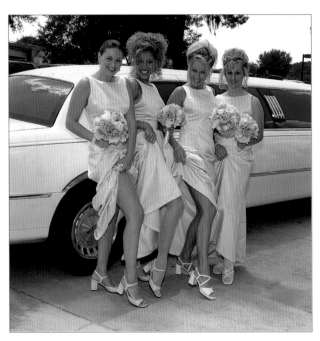 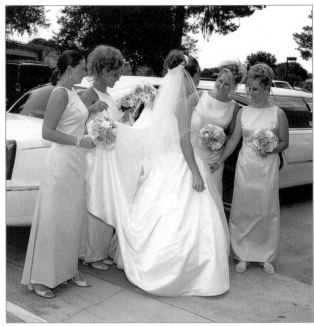

The women a bride chooses as her bridesmaids may be colleagues, friends, sisters, relatives—people she has fun being around. You can show this special, fun relationship by using offbeat groupings when photographing the women. Remember, not every pose has to be set up—sometimes all you need to do is gather the bridesmaids around the bride and let the different personalities take over! Not only will you have more fun on the shoot, but your images will also reflect the real character of the women the bride selected to share her special day.

PHOTOSHOP TECHNIQUE

Techniques for creating collages are covered in chapter 7, but you can use the same technique to create a collage effect to highlight one aspect of an image—a face, the bouquet, the rings, etc. In the photo to the right, the faces were accented to show off their silly expressions.

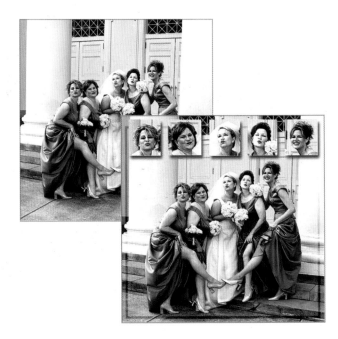

1. Open an RGB image.
2. Select the area to be highlighted. Copy this area and paste it to a new layer. Position the copied area.
3. Go to Layer>Layer Style and add a drop shadow or other effect.

Additional effects can be applied. Here, a sepia tone was added to the faces and a ten-point stroke was added in brown around each inset photograph.

The Groom and Groomsmen

My attitude toward formals is to give the couple what they want. If they want traditional images, I work carefully to get every element just right—making sure the legs of the groom and groomsmen are together, etc. As photojournalism increases in popularity, though, more and more couples prefer relaxed group shots. We discuss this in the consultation (but even if they prefer casual shots, I make sure to get a few posed formals to a add a polished look to their album).

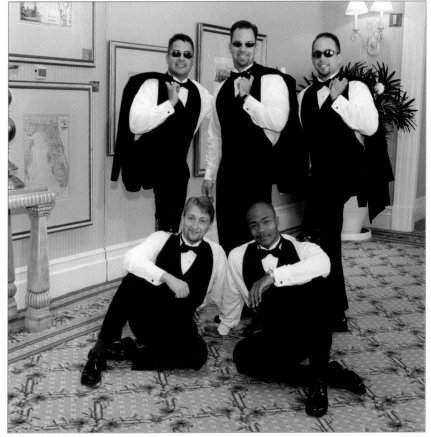

Once I finish those traditional formals, it's time to have fun. With the posed images out of the way, your subjects should be loosened up and ready to do what you ask them to do. My biggest sales now are the fun, spirited group shots that come out of this part of the shoot. If you're like me and have been studiously setting up group shots for years, you'll probably also find that this is a great change of pace.

When working with guys, you may want to suggest they bring some props. Sunglasses are always in style, and cigar smoking is very popular right now—and these simple props can really make an image.

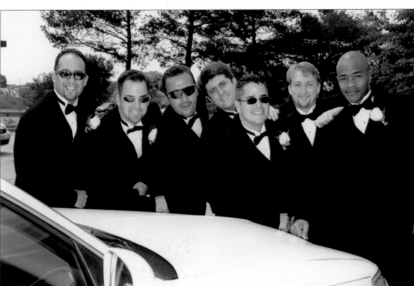

During the formals, there are a couple of challenges I often encounter. First is the troublemaker—the groomsman or bridesmaid who either wants to get right to the reception or doesn't like having

his/her picture taken. What do I do? I make it a point to mention that person's name while I'm setting up the shot ("Bill, what do you think? Should we get these formals done so we can get to the reception?" or "Jane, can you help me fix this bridesmaid's dress so we can get to the party?"). Singling out the troublemaker usually helps to bring him/her down to a low-key attitude—and gets them caught up in the shoot without really knowing it.

Another common problem occurs when every guest wants to take their own pictures of the groupings. After twenty years of doing weddings, I've learned better than to fight the crowd. In fact, I invite them to stand next to me—my only request is that they shoot as fast as I do. I even comment to the bride and groom that it's every-one's event and we should all have some fun. As you can see, this creates a much better atmos-phere. Additionally, when working on these images in a church, I'm usually shooting at ⅛ second on a tripod, so guests' snapshots will have a dark and unattractive look on the background (and will be on an angle, since I ask them to stand next to me).

PHOTOSHOP TECHNIQUE

Glare can be a problem on both indoor and outdoor shoots. Here, there were spots of glare on the guys' sunglasses. While it wasn't terribly distracting, it's easily remedied. To start, zoom in closely on one of the faces. Then, go to the Clone tool. Select a small, soft brush and set the opacity of the Clone tool to about 50%. This will help you maintain the sense of a shiny surface (so the glasses don't end up looking like big black spots) while eliminating the bright highlight. Press Opt/Alt and click to sample a nearby area (here, a dark area of the glasses). Click the Clone tool over the glare to begin concealing it. For irregularly shaped areas, you'll probably need to use several brushes of different sizes. This technique was also used to remove a small area of glare on the glass covering the photograph behind the guys.

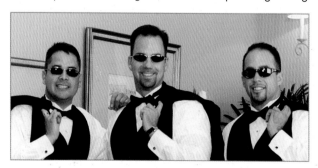

On Location

It was about 95° outside at Cypress Gardens on the day I took these images—so the last thing I wanted to do was make the bride, groom and little girl wait around! However, I *did* want to create some prints for competition, so I needed to work quickly but carefully.

For each shot, I began selecting the beautiful location (here, with the late afternoon sun behind the subjects). With the sun in this position, I placed the subjects so that the light created a perfect Rembrandt pattern on their faces. No additional light or reflectors were needed. I moved close to the subjects and metered the shadow area using a Pentax spotmeter.

> With the sun in this position, I placed the subjects so that the light created a perfect Rembrandt pattern on their faces.

Then, I shot a Polaroid to make sure everything was right. After double-checking the scene through my camera, I refined each pose as needed. I composed each photo according to the rule of thirds, so the viewer's eyes are drawn across the frame to the subjects. If the subjects were centered, they would have much less impact.

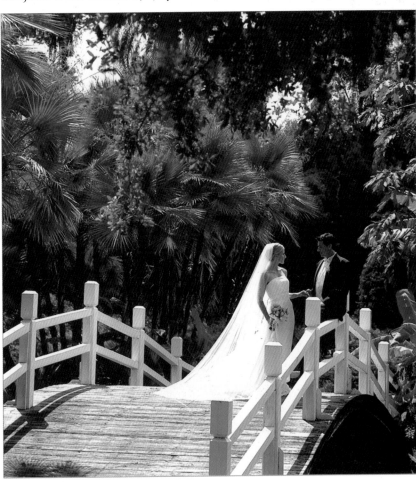

In the portrait of the bride and groom (previous page), the bride's veil creates a long, flattering line that accents the S-curve created by her body. In the photo below, notice the beautiful highlight on the little girl's arm and the light on her hair that separates her from the background.

Because I made the most of the area and the available light, the total time required to create these images was under twenty minutes!

PHOTOSHOP TECHNIQUE

The image used in print competition is shown below. It employed a number of digital effects to eliminate distractions in the background, soften the image and create a unique border. For more on this image, turn to page 117.

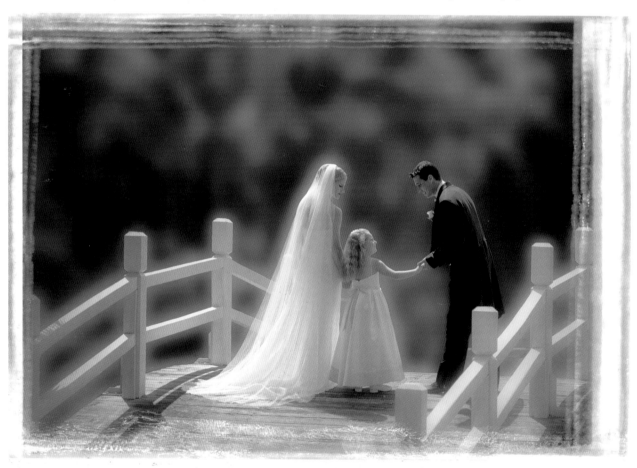

Silhouettes and Backlighting

Silhouettes can create a sense of unity between the bride and groom—if you aren't capturing them, you are missing out on what could be one of the most important shots in the couple's album! For the best results and to minimize specularity, look for a window that does not have direct light coming through it. I prefer a window with flat light.

To create a high-quality backlit image or a pure silhouette, there are three key ingredients: composition, appeal and metering. Because the couple will be shown as "shapes" with little (or no) detail, you must compose the image carefully. Try to create graceful curves, diagonal lines and other shapes that will catch the viewer's eye. In my opinion, you must have the face(s) in a perfect profile to make these shots really work well.

Since there is little detail, facial expressions and other details that add appeal to an image will be missing. You must compensate by posing the couple (or subject) in such a way that the position of their

For the best results and to minimize specularity, look for a window that does not have direct light coming through it.

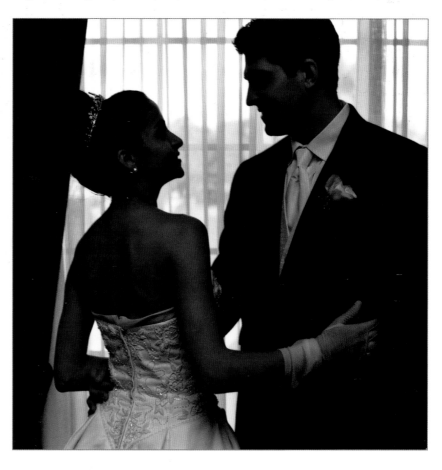

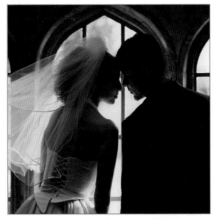

bodies tells the story and communicates an emotion—whether it's romance, contemplation or pure joy. I like to start with the couple facing each other. Their bodies should each be at a 45° angle to the camera, and their faces turned in profile. Again, since shapes are critical here, stretch or bend their bodies so they look their best.

Finally, metering the scene will ensure that you capture/eliminate detail as you desire. (If you don't have a meter, try setting your lens to f-5.6 and ¹⁄₃₀ second—and if you want a little detail, bounce flash [set two stops less] off the ceiling and onto the subject.)

PHOTOSHOP TECHNIQUE

When working with silhouettes and backlighting, exposure can be tricky. If you aren't quite happy with the balance between light and dark, the Curves can be extremely useful for creating the tonal balance you want.

As noted in chapter 3, you should begin by using the Eyedropper tools—but in the reverse order you would with most images. Start by setting the white point by clicking on the lightest area of the image (probably somewhere on the window). Next, select the black eyedropper and identify the area you want to be the darkest in the frame. This may take some experimentation to get just right, as you'll need to weigh the importance of the graphic impact of *shapes* against the value of revealing *textures*.

Once you are happy with the effects you have achieved, you may want to adjust the midtones slightly by pulling up or down on the center on the curve.

The photos to the right show two different versions of the same photo—and there's quite a difference!

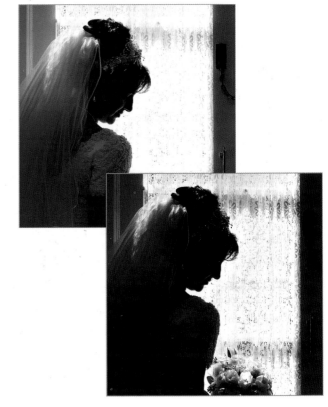

The Reception

The bride and groom have spent a lot of time and money making the reception area special, so don't forget to document it in detail. In addition to creating images for the couple, you'll be creating images that you can give the caterer, the florist, the wedding director, etc.,

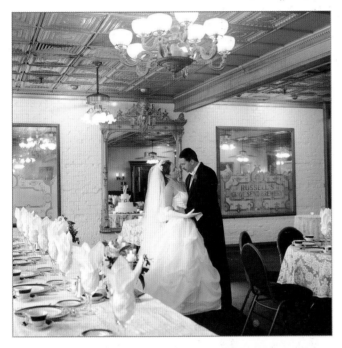

to showcase their work. Make yourself an appointment with these important members of the wedding industry in your area, and start building a rapport. A little investment (perhaps an 8" x 10") can generate a lot of referrals—brides are always interested in advice and recommendations from the other people working on their wedding, or they may learn about your work by seeing one of those 8" x 10"s displayed at their florist, cake shop, etc.

If possible, try to get the bride and groom into the reception hall before it opens. In the photos to the left you can see how, after documenting the area, I put this couple in two photos of the hall. I placed them strategically after metering the ambient light. In the first photo (top), I placed a Quantum flash behind them. The available light on their faces read f-5.6, so I set the light two stops hotter (to f-11). Having them tilt slightly created a sense of movement. This was one of their favorite images from the wedding!

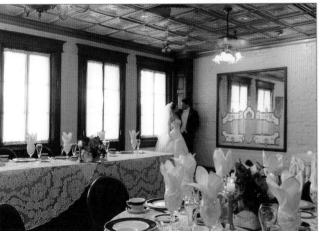

When I arrive at the reception, I like introduce myself to the maitre d' (or banquet manager). Since we'll be working in the same space, this helps get things off to a good start. Next, I like to photograph each of the tables. Getting this done right away means that I won't be in the way when the main course is served—which makes the servers happy! I charge $25 per table for this service, and it must be contracted by the couple in advance. I do two shots of each table, and also double-light each.

Pay attention to the details—place settings, décor, wine selection, seating arrangements, presentation of the food, etc. Many couples tell me later that they were so so caught up in the action that they

don't even remember what the decorations looked like. Leave yourself plenty of time to set up these shots. Remember that the maitre d' (or banquet manager) and servers have a job to do, too, and need to work in the same space. The bride and groom want great pictures, but they also want the service to go smoothly.

Once I have completed photographing the area, I step back and photograph the action. I don't take any more setup shots until the cake cutting.

Once the action begins at the reception, you need to get yourself into a photojournalistic state of mind. Begin looking for moments, and try to anticipate photo opportunities. Roam the hall, watch for friends admiring the bride's ring, for Mom

Roam the hall, watch for friends admiring the bride's ring, for Mom planting a kiss on the groom, etc.

planting a kiss on the groom, etc. If you check with the bandleader or DJ, you can often get a good idea of what to expect and where you'll need to be to capture it. Of course, you should make sure to have a selection of lenses ready, your backs prepared, fresh batteries—and all the things you need to work with minimal interruptions.

Often, during the reception, guests will ask if you can photograph couples or other groups. Of course, I don't refuse—but I *always*

make the bride and groom my priority. If they need my attention, I ask the other group to wait. This is where a service like eventpix.com can be useful—with it, everyone who attended the wedding gets a password and can use their computer to log on and see (and purchase) the images. Therefore, you don't have to rely on proofs being passed to every interested person.

PHOTOSHOP TECHNIQUE

Discolorations can occur on clothing, tablecloths, walls—and here as light water damage to the ceiling around the chandelier. How to approach the problem will depend on the individual image, but there are some good strategies that often yield success. The first step in each process is to select the area.

For light discolorations, consider using an adjustment layer (Layer>New Adjustment Layer). A Curves layer will likely work the best. After creating the new layer, adjust the curves in the dialogue box that appears—working on each color channel individually as needed.

For darker discolorations, consider following the procedures covered on pages 43–45 for removing distractions.

Here, it was important to maintain the texture on the tiles, so strips of the unstained ceiling tiles were copied onto new layers and moved over the stained ones. The Edit>Transform> Distort function was used to fit the new data into place.

Capturing the Moment

Weddings are full of emotions—but capturing the genuine joy and romance of the day can still be challenging. You have to be on the lookout all the time, and ready to act when you see a moment happening. These opportunities can pass in just seconds—so you have to be prepared.

In the first photo (left), we had a groom who just couldn't wait to kiss his new bride. I just kept taking shot after shot as it happened. Does it matter that her eyes are closed? If the bride likes the image, then no. A natural, spontaneous image like this might very well turn out to be her favorite one from the wedding!

The second photo (center) illustrates something that happens from time to time. After I had done my posed image of the couple in

the setting, the magic and the natural feelings were right around the corner. I kept shooting after I was "done"—and this shot was actually better than the one I set up!

When you're capturing those spontaneous moments, don't forget about composition. As shown in the third photo (right), architectural elements can be used to add a bit of drama to a simple kiss portrait.

Photo three also depicts a simple kiss—but look at how the location adds to it! It really pays to build your library of locations. If you have some favorites, show them to your clients. Also, if you have photographed a wedding in the same venue where a new bride and groom are planning their event, showing them the result you have achieved there can be helpful.

The final photo (facing page) was taken at a wedding where a fireworks display was presented at the reception. To capture the bride and groom in front of a sky full of color, I began by placing the cam-

era on a tripod. I exposed for one set of fireworks, then opened the lens as needed for the additional sets. You can also use a gel over the flash so that its light blends in with the colors in the sky.

PHOTOSHOP TECHNIQUE

Photoshop 7 features a number of irregularly shaped brushes, allowing you to create more artistic effects. In this example, a large-bristled brush was used to create an edge effect on the portrait seen on the facing page.

1. Open an RGB image.
2. Create a new layer. Work on this layer.
3. Fill the new layer with white (Edit>Fill).
4. In the Layers palette, reduce the layer opacity to 50% (so you can see the photo under the layer).
5. Select the Eraser tool and choose a large brush of any type and size you like. In the Options palette, set the opacity to 100%.
6. Erase as much or as little of the white layer as you like, revealing the underlying image.
7. Set the opacity of the white layer back to 100%.

Putting Your Images to Work

USE PHOTOSHOP TO INCREASE
THE VARIETY OF YOUR PROD-
UCTS AND THE POWER OF
YOUR MARKETING.

CREATIVE MARKETING WITH PHOTOSHOP

Once you have become comfortable using Photoshop to retouch, crop and enhance your images, why not combine those images to create your own unique marketing products? By developing templates, you can efficiently produce your own promotional mailers, brochures, business cards, gift cards and posters. When you do it yourself, you can afford to vary the images on your marketing pieces and change the text as often as needed. You can also print a few at a time. If you don't have a printer (or don't have one that will produce the desired quality), you can use your lab

Why not combine those images to create your own unique marketing products?

When you create your own marketing pieces, you can afford to vary the images on them to show the full range of your work and to change the text as often as you like. Images by Deborah Ferro.

or a copy center (we use Kinko's) to print your materials on card stock or as posters at a very reasonable price.

When printing from a digital file, you will want to ask the printer what resolution they need to produce a high-quality printout, and whether they prefer a vertical or horizontal format (if you'll be printing the materials on your equipment, check for this information in the user's manual that came with your printer).

You can create different cards to represent each aspect of the photography that you offer your clients.

You can also request that your lab or professional printer send you a sample digital file and print to help you calibrate your monitor for the best color results. By comparing the appearance of the file on your screen to the resulting print on their equipment, you can adjust your monitor to ensure your image will print as you expect it to.

When creating business cards, you can create different styles to represent each aspect of the photography that you offer your clients. This makes it affordable to have a different business card for weddings, portraits and commercial photography.

Marketing professionals suggest that you only have seven seconds to make a first impression on a potential client, and that your first impression will be the one that lasts in his or her mind. People today are overwhelmed with junk mail and business cards. To ensure that yours will not end up in the trash, you will need to spend more than seven seconds on creating a marketing piece. You will want your marketing piece to have enough visual impact that the client will not only remember who you are for more than seven seconds but will also decide to call you to book an appointment!

"The Look of Love" is an example a marketing card that is sufficiently versatile to be used as a wedding brochure cover, a promotional mailer or a business card. Image by Deborah Ferro.

"The Look of Love" (facing page) is an example of the type of marketing card that is sufficiently versatile to be used as a wedding brochure cover, a promotional mailer or a business card. Here's how to use your own image to make a marketing card like it:

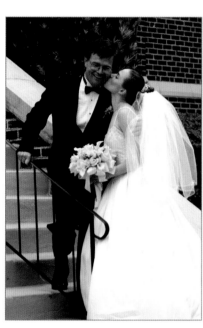

1. Open the image you want to use on your card (left).

2. Color correct the image and do any retouching work that might be necessary.

3. Use the Image>Adjust>Desaturate method (see page 30) or the Lab Color method (see page 27) to make the image black & white.

4. Make a copy of the Background by dragging it to the New Layer icon at the bottom of the Layers palette.

5. Blur the entire image by going to Filter>Blur>Gaussian Blur.

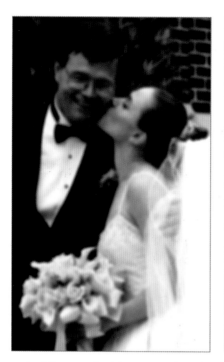
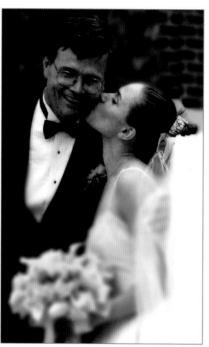

The image on the left shows the result of blurring the image with the Gaussian Blur filter. On the right, the sharpness has been restored in the faces.

6. Choose the Eraser tool and select a soft brush. Working on the blurred layer, erase the faces so the sharp layer shows through. Then, go to the Layer Visibility icon (the eyeball) in the Layers palette. Click the icon off and on once or twice to ensure you have erased all of the blurred area.

7. Duplicate the blurred layer again and add a bit of noise (this will make it blend better with the faces from the original images). To do this, go to Filter>Noise> Add Noise and check the Uniform box.

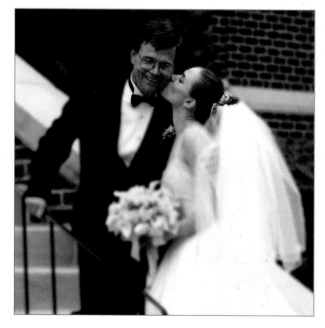

8. Flatten the image (Layer>Flatten Image) and sharpen (if needed) by going to Filter>Sharpen>Unsharp Mask. Save the image.

9. To create the "Look of Love" card, crop this image to 5" x 5" at 250dpi (or whatever your printer requires).

10. If you like, you can add an edge effect to the image. In our final card, the Round Rippled Paper Effect filter from Extensis PhotoFrames was applied. You can create custom border effects in Photoshop by applying your own combination of selections, filters, layer styles and other tools (see pages 66–73).

11. Create a new document that is 5" x 7" at 250dpi (or whatever your printer requires). Set the background to white.

12. Select the Move tool and drag the cropped black & white image into the new document. Place it a little above center.

To Add Text

1. Click on you Text tool in the Tools palette.

2. Type the "The Look of Love" above the image, using a legible font in any size or color you like.

3. With your mouse, click and drag across the text to highlight it. To change the font or font size, click on the appropriate

window in the options bar and use the up and down arrow keys to scroll through your available fonts, or to adjust the the font size up (up arrow) or down (down arrow).

4. After you are happy with your text you can move it around with the Move tool. When you have placed it where you want, continue on (you can always go back later and edit the layer if needed).

5. Using your Text tool again, type your studio name in the area below the image and repeat the previous instructions until you get the wording and look you want. (If you have a studio logo, you can also place it here by opening the file in Photoshop, then using the Move tool to drag the logo into the "Look of Love" card.)

6. Save a copy of your card as a PSD file so that you can change it when needed.

7. After saving it as a PSD file, flatten the image.

To Add an Outline
1. With the Rectangular Marquee tool, click and drag to create a selection box around the studio name or logo.

2. Hit Ctrl + H (for PC) or Cmd + H (for Mac) to hide the selection indicator (the marching ants).

3. To create a line around this selection, go to Edit>Stroke. We used the settings seen here.

4. To select a color for the outline, click on the Color swatch in the Stroke dialogue box. This will activate the Color Picker. Set the desired color in the Color Picker and hit OK to return to the Stroke dialogue box.

5. Deselected the invisible marching ants by going to Select>Deselect.

6. Save the completed card.

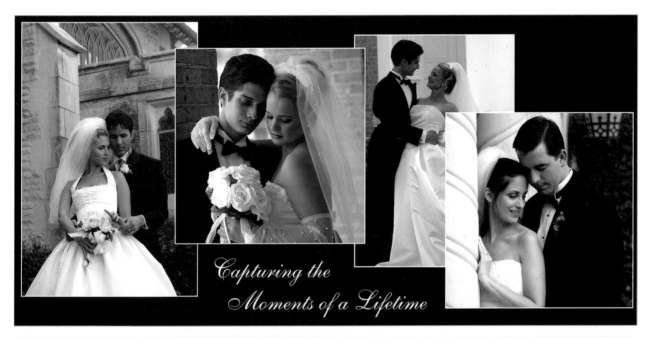

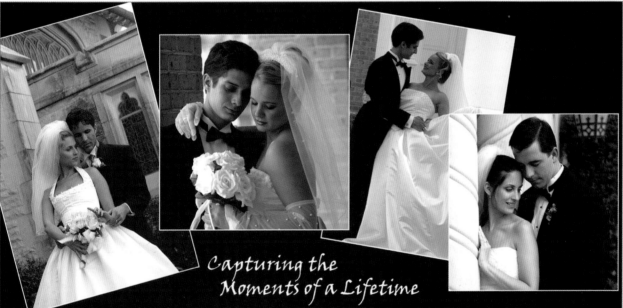

Images by Deborah Ferro.

PROMOTIONAL MAILER

When sending out any images that represent your studio, make sure that they have impact and a consistent look. A black background is a sure way to make your images pop—just make sure that it is a deep, sharp black! The above two examples are 4" x 8.25" promotion cards that we arranged in two different ways. Importing these photojournalistic images from my digital camera, I converted them to black & white using the Lab mode for color conversion (see page 27).

To create the first style of card (the top image seen above), we used the following procedure:

1. Create a new document that is 8" x 16.5" at 250dpi (or whatever your printer recommends).

2. Go to Edit>Fill to fill the document with black. Select black from the Use pull-down menu. Set the Blending to Normal and the Opacity to 100%.

3. Open two 5" x 7" black & white images and two 5" x 5" black & white images at the same resolution as the new document.

4. Create a white stroke around each image. To do this, in each image, select the entire image area (Select>All). Then go to Edit>Stroke. Set the width (and color) of the stroke as you like.

Adding a stroke to the image.

5. With the Move tool, move the images one at a time onto the new document with the black background.

6. To adjust the size of each image for better placement, go to Edit>Transform>Scale and click and drag the handles at the corner of the bounding box. To avoid distorting the image, hold down the Shift key as you reduce or enlarge each image. When you are happy, hit Return or double-click within the bounding box.

7. To arrange the images in front of or behind each other, drag one layer above or below each other in the Layers palette.

8. Add text with the Text tool as described on pages 105–6.

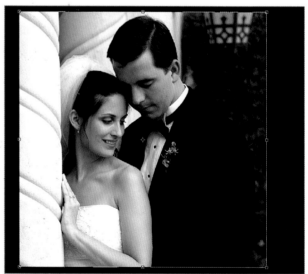

Adjusting the size of the image.

9. Before you flatten your document, save it first as a PSD file. This preserves the layers so that you can make any future changes that are needed (including swapping in different images).

10. If needed, reduce the image size by going to Image>Image Size.

To create the second style of card (the bottom image on page 107), we used the following procedure:

1. With all four images in place, go to the Layers palette and click on the layer of the image you want to rotate. Then, go to Edit>Transform>Free Transform. When the bounding box appears, click and drag on one corner of the bounding box to rotate the image. When you are happy, hit Return or double-click within the bounding box.

2. Since the layout of the images has changed, you may need or want to fine-tune the text (see pages 105–6).

We used the same techniques discussed in this chapter to create this advertisement, then ran it in an upscale bridal magazine that caters to brides in our area.

Signature Studio
Rick Ferro & Deborah Lynn

Watercolor cards make a great thank-you note for your clients, as well as a perfect invitation, thank-you note or Christmas card that brides can purchase from you. Image by Deborah Ferro.

WATERCOLOR CARDS

Watercolor cards make an excellent thank-you note for you to send to your client. We like to put one of the bride and groom's engagement images on it, or an image from the wedding. We also offer the watercolor cards for sale. We package a set of twelve in a black box from Albums, Inc. and decorate it with a gold bow. We suggest to the brides that these cards can be used for wedding invitations, thank-you notes or Christmas cards.

Watercolor cards make an excellent thank-you note for you to send to your client.

There is a wide selection of media available for creating watercolor cards. When using a folding card you will want to make a template that is exactly the size of the entire card so that you can print the front and back of the card at the same time. We put our studio name and our individual names on the back of each card.

If you are printing your own work on your inkjet printer, you can simply print an image onto watercolor paper without any applied filters and still achieve an artistic look. We use Epson watercolor paper on our Epson printer and deckle the edges of the paper by hand.

To begin, you'll need to carefully measure the card onto which you'll be printing your image. To do this, open up the card so you can see both the front and back.

Then, follow the steps below:

1. Go to File>New Document and enter the size of the unfolded card. Set the resolution at 150 dpi (for watercolor cards you generally don't need a higher resolution than this, but check your printer to make sure.) Select white for the Background Color.

2. Open the image that you want to put on the front of your card. If necessary, flatten the image.

3. Go to Image>Image Size and change the resolution to 150 dpi. (The resolution of your background will need to match any additional layers.)

4. Drag your image onto the new document and place it on the right half. (You may find it helpful to drag a guide from the left ruler over to the middle of the document to remind yourself where the fold in the card will be.)

5. On the left side of the card (the back), add your name, logo or any other information you like (see pages 105–6 for tips on adding text).

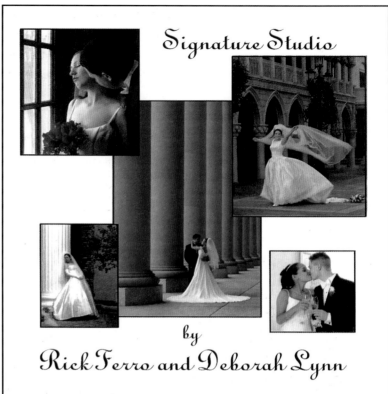

Our 6" x 6" business cards (here seen front and back) are easy to create and can be updated easily to reflect our latest work.

▦ BUSINESS CARDS

While we completely agree that word of mouth is the best form of advertising, you cannot overestimate the importance of having an effective business card. You should always have your card handy. At weddings, make sure to hand a card to the caterer and any other vendors working on site.

We made our business card in a nonstandard size—6" x 6". One of the reasons we made this decision was simply because it *was* nonstandard. Everyone has wallet-sized cards, but we wanted something that people wouldn't lump in with the others or throw away. Is it costly? A bit—but when you hand one to a person who is interested in booking a wedding, it's worth every penny. We're on the high end, but that's what it takes to meet the demands of our clients.

> When you hand one to a person who is interested in booking a wedding, it's worth every penny.

As you look at our card, you'll notice that it (like our other self-promotion pieces) showcases both traditional and photojournalistic images, color and black & white images, and shows digital colorization. Potential clients who see this card know immediately what they can expect from our wedding coverage.

We are now stressing that prospective clients should visit our web site. We don't put our address on our cards, preferring that clients

call and schedule an appointment to come to our studio. This also gives us a chance to ask that Mom and Dad come, too—since they are usually the ones paying the bills!

To create a card like this, follow the steps given on pages 60–66, but assemble the images for the front of the card on a white 6"x 6" background. The back of the card can also be created in Photoshop on a new document file with the same dimensions and resolution as the file for the front cover. If you prefer, you can also do this text-only part using your favorite word-processing or layout software.

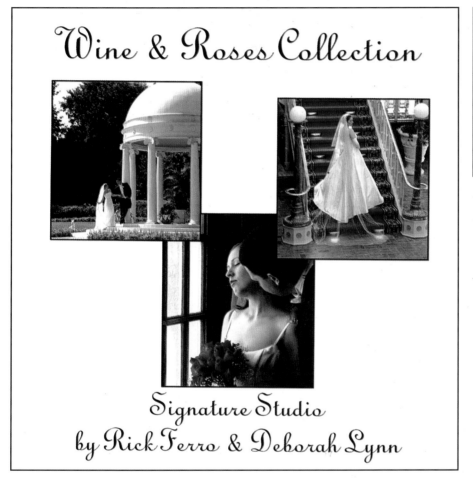

Wine & Roses Collection

A collection of special moments shared by two of your wedding. Classic images that will become more precious and valuable as the years come and go for you and your family.

- A complete Engagement Session on location or in the studio.
- A complete Bridal Portrait Session on location or in the studio with photograph for press release.
- Two parent albums containing 20 prints each.
- 16x20 wall portrait or 11x14 Signature Portrait with sign in board & frame.
- 6 hours wedding day coverage.
- Renaissance Album consisting of 42 sides.
- Web album.

$ X,XXX.XX + 7% tax

www.rickferro.com
Phone: 555.000.0000
800.000.0000

The larger size of our business card allows us to showcase a range of work (here traditional and digital handcoloring) rather than just one image.

10

PRINT COMPETITION WITH PHOTOSHOP

by Tim Kelly, M.Photog., Cr., F-ASP

If you take print competition seriously, you know how difficult it can be to get judges to see how great your photograph really is. Many refer to salon competition as "a game," while others believe there is a lot of "luck" involved. If you consider it a game, you should be playing to win! And, I find, the harder I work the luckier I get! On

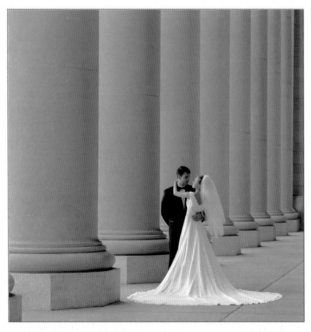

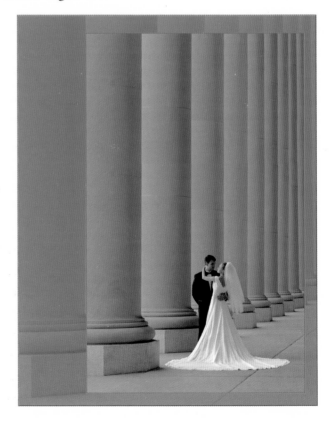

Above—A striking bride and groom in front of rows of massive columns. Right—With the addition of extra height, improved dynamic placement and a phantom image background of columns, its impact will now grab the attention of the jurors.

Above—This photo of a bride and groom on a staircase is very well rendered with a high camera angle, slight softness and natural-looking lighting. *Right*—Converted to black & white, the new version is placed on a white background. Photo edges and an additional pinstripe complete the presentation.

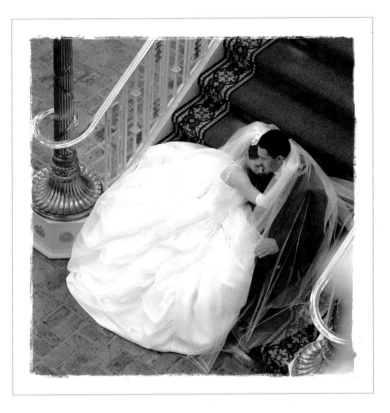

the other hand, if you take it too seriously, you may not have the freedom to be creative, for fear of breaking some rule that might sink your print's chance of an honor.

I have been involved in print competition for over thirty years and judging for more than a decade, but my degrees alone account for just a small portion of my experience. It has been my privilege to print and finish hundreds of highly awarded entries for some of the nation's finest image makers.

Nowadays, we no longer use darkrooms, dyes, airbrush or pinstriping tape. We use Photoshop and the finest digital printers available. Everything has changed—yet nothing has, actually. Sloppy work can never become art, no matter how much you spend on it, but a fine image with great potential can easily be overlooked if the print quality and presentation aren't right. Let's look at a few examples that take a really good image to another level.

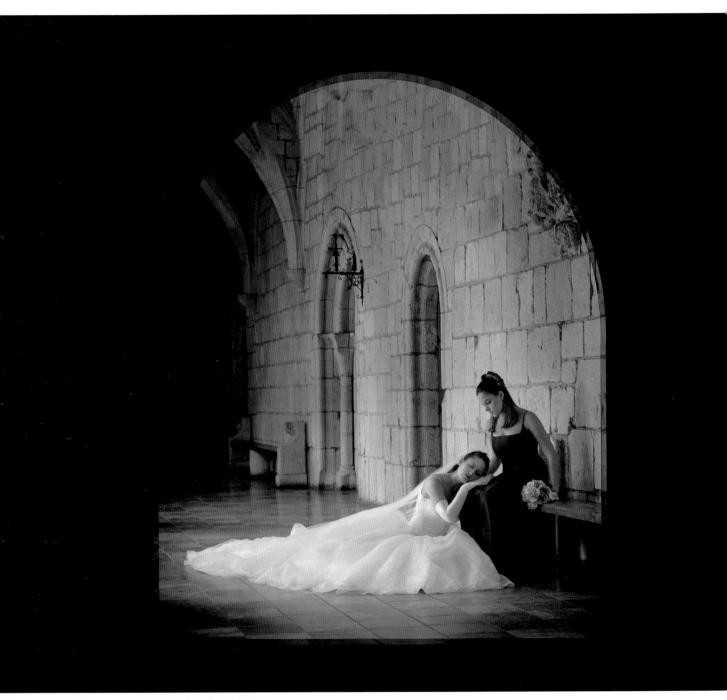

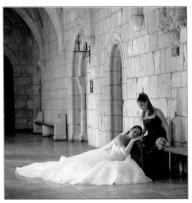

Left—*A wonderful mood was captured here, and while the natural lighting is severe, it does add to the image. There are a few distractions that need to be addressed.* **Above**—*Additional height was added, and the low-key arch was used for framing. Of course, normal retouching is always part of the process. Final printing for competition is always quite deep, usually at least 20% darker than normal.*

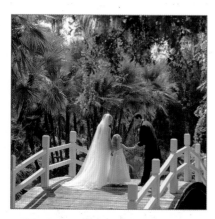

As you will see, the better the original image is to start, the more likely it will score well. Your opportunities are better when you can spend time enhancing your image, not just fixing it. Imagine a bride: natural beauty will certainly help, won't it? Now add the assistance of a top makeup artist, hairdresser and dress designer, and you have something spectacular. That's exactly what you need to do for your competition prints.

Top Left—This image, backlit in full sun, is beautifully posed and has great expression to boot. However, the sharp tropical background, even after retouching out the hot spots, was too distracting. *Bottom Left—When careful retouching still didn't solve the problem, we diffused the background—over and over again. Finally, we used a heavy Gaussian Blur and some photo edges to complete the fix.* *Below—Finally, we printed it loosely in a 16" x 20" format to create the "postcard" feel.*

11

WEB SITE DESIGN
FOR PHOTOGRAPHERS

by Paul Brooks Rose

When creating Rick Ferro's web site (www.rickferro.com), we were challenged with balancing load time versus image quality. Extremely high quality photographs may take longer to load, thus causing the viewer to wait for images to appear. Some viewers may become impatient and leave the site. Therefore, it was necessary to balance the photo quality with load time.

When low quality photos are used, the viewer does not get a true representation of a photographer's ability—and Rick Ferro is a top photographer, so this was important to his continued success. To achieve a higher quality image, Macromedia® Flash® was used in several locations because it presents the images in a bitmap format, which provides a clearer representation of the images.

In order to keep the interest of the viewer past thirty seconds, the normal amount of time a visitor stays within a web site, it was important that the site feature a first-class "navigational system" that was user-friendly, and designed to capture the prospective client's interest by employing the display techniques listed below.

▦ INTRODUCTORY PAGE

Because first impressions are all important, for the entry page, we chose a Macromedia Flash presentation that provides a unique introduction to Rick Ferro's award-winning style. The photographs chosen were all award winners from Rick's worldwide competition entries. A small sound bite of music was added to enhance the view-

Rick Ferro on the Importance of Web Sites

In the last year, I have been doing a lot of seminars. One of the questions I asked at each venue was how many of the attendees had a web site or an e-mail address—and I was very surprised at how few said they did!

Having an effective web site has revolutionized my business. It took me years to build my business, but my web site now lets me sit at home and go on line to maintain it (and generate new business). While I do not list prices on my site, everything else a bride needs to know is instantly available to her. After reviewing my work, she can e-mail me to check my availability for her wedding date.

Via e-mail I can talk with the bride about the styles she prefers. I can also send her updates and reminders, and even welcome the couple home from their honeymoon by sending them an e-mail with a thumbnail photo from their wedding as an attachment.

Not having a web site is like not having a camera—but creating an effective one requires quite a bit of knowledge and experience. I am now working with Paul Rose, my second web master. He builds and updates my site, gets it on search engines so interested people can find it, etc.—all of the things that make the site a truly powerful tool.

By keeping the focus of the site on the images and minimizing text, my site has evolved to the point where it is responsible for generating 50% of my business. It has also allowed me to dramatically reduce my spending on advertising—a welcome side effect!

ers experience. However, visitors were also given an option to skip the Flash presentation and go directly to the home page, which provides a snapshot of vital information regarding the photographer's physical location, phone, etc., so that prospective clients can easily contact him.

▤ SITE MENU

The menu, which is always visible, was created using Macromedia Flash. The user simply touches the menu button to reveal the entire scope of the web site and the information contained therein. Because the menu is easily accessible from all pages of the web site, the user

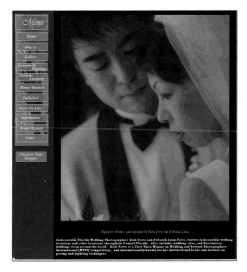

always has the opportunity to view other pages or return to the home page. When the menu is not displayed, Rick's logo ("Signature Series") is visible, with an award-winning photo in the background.

Who Is. The "Who Is" page is noteworthy because it shows a portrait of the photographer and includes a biography of the photographer's experience (similar to a résumé). From this page, visitors can also view Rick's many accomplishments and awards if they have further interest.

Galleries. The button takes visitors to the "Galleries," where they see a series of photos changing one after the other. Here, the visitor has a choice of several galleries (a gallery directory). The viewer may choose from a traditional, photojournalistic or engagement gallery to preview the images.

The traditional gallery consists of thumbnail photos that lead to a slide show presentation as each image is selected. It is up to the user as to how much detail they wish to view.

Left—The "Who Is" page provides bio-graphical information. **Right—***In the galleries, visitors can view sample images.*

Individual galleries allow the visitor to explore a variety of different types and styles of images.

The photojournalistic page incorporates a scrapbook as well as well-placed still shots of interest. The newspaper background is also unique and gives the feel of a journalistic look, adding to the sense of excitement.

Locations. The site includes a page that features wedding venues throughout Central Florida and is a constant work in progress as new locations become available, and as old ones become unavailable or offer new options.

The locations pages are updated regularly as new locations become available.

Honey Mooners. This is a favorite of our photographer. Here, he displays photographs of some of his recent weddings—including Disney weddings. Couples love this and Rick gets a chance to show off his versatility.

Left—The "Honey Mooners" page showcases some recent work. Right—Rick Ferro's web site also lists his publications.

Published. The "Published" page features articles displaying Ferro photos used in commercial advertising his books and other media materials in which Rick Ferro's images have appeared.

Ferro On Line. "Ferro On Line" is a work in progress. In the future, Rick will be adding many photography product lines as well as information regarding his publications, articles about the Ferro style, teaching techniques and tools of the trade. Ferro On Line will become a friendly place for other photographers to visit when looking for photography information.

Information. The "Information" button is one of the most important choices because it is here that the client requests photography services. This page should be user-friendly. It must also include all of the specific information fields that are required to create clear

*Left—Clients can request photography services directly from the web site. **Right**—Providing direct web links to preferred venues, Rick Ferro's site is an excellent resource brides will want to visit again and again.*

communication between the client and the photographer regarding their respective needs. It is with this information that the photographer will make his first contact with the client.

Links. The "Links" page is an important tool that can be used by the photographer as well as the clients to find other vendors or information related to client needs. The more reciprocal links there are, the more popular a site will appear to search engine listings. Many search engines rate a site according to popularity, and links are the key to creating that popularity in the rankings.

FINAL THOUGHTS

The evolution of photography into digital has brought with it so many wonderful creative opportunities—from watercolors, to collages to digital albums. We are now able to do our own retouching and gain more control over our images. The possibilities are endless, but so are the hours that you can spend learning Photoshop and managing your digital images. Before you know it, it's 3A.M. and you are still sitting at your computer and now MIP (Missing in Photoshop). As we are transitioning to become a completely digital studio, finding the balance between business and personal time is an ongoing challenge. Therefore, we make the following suggestions (as much to ourselves as to you):

1. **Jump in headfirst, not checkbook first.** Research what you buy and buy only what you can afford and have time to learn to use.

2. **Get involved.** Local photographic organizations and groups like the NAPP have already been where you're going—so you don't have to reinvent the wheel! Instead, learn how others are coping with the challenges and study the solutions they have devised.

3. **Don't retouch every image.** Show the client one retouched image, then offer this service at a fee. Time is money, so make sure you are being compensated.

4. **Archive.** Keep two copies of all your original images and store one copy offsite.

5. **Rest.** Even God rested on the seventh day. Yet, like many photographers, our greatest challenge is making sure we take personal days where we don't answer the phone, go to the studio or *turn on the computer!*

We hope that you have found this book to be both helpful and encouraging as you make your own digital transition!

INDEX

RESOURCES

Albums—
Albums, Inc., 752-A Winer Industrial Way, Lawrenceville, GA 30045, www.albumsinc.com, (800)622-1000
Jorgensen, www.jorgensen.com.au
Renaissance, www.renaissancealbums.com

Backgrounds—
Denny Mfg. Co., PO Box 7200, Mobile, AL 36670, www.dennymfg.com, (800)844-5616

Education—
Rangefinder magazine, PO Box 1703, 1312 Lincoln Blvd., Santa Monica, CA 90406,
www.rangefinder-network.com, (310)451-8506

Film—
Fuji Photo Film USA, Inc., 555 Triton Rd., Elmsford NY, 10523, www.fujifilm.com, (800)755-3854

Lighting—
Quantum Instruments, Inc., 1075 Stewart Ave., Garden City, NY 11530, www.qtm.com, (516)222-6000

Other Books from
Amherst Media

Also by Rick Ferro . . .

Wedding Photography
CREATIVE TECHNIQUES FOR LIGHTING AND POSING, *2nd Edition*

Learn the secrets of shooting elegant, artistic portraits as Rick Ferro takes you through over seventy-five of his highly acclaimed, award-winning portraits, explaining how to capture breathtaking portraiture of the bride in the studio, the ceremony, wedding party and the newlywed's families. Learn techniques for non-obtrusive coverage of the ceremony itself, as well as how to pose and shoot photos of the couple at the altar after the ceremony. You'll learn to set up an efficient shooting system that will save time and reduce stress when doing portraits of the wedding party. Finally, you'll learn to select perfect locations and take great images of the newlyweds, including ring exchanges, silhouettes and more. $29.95 list, 8½x11, 128p, 70 full-color photos, index, order no. 1649.

" ...generously illustrated with excellent color photographs, including both traditional wedding poses and creative techniques." —*WPPI Photography Monthly*

Outdoor and Location Portrait Photography
2nd Edition
Jeff Smith

Learn how to work with natural light, select locations, and make clients look their best. Step-by-step discussions and helpful illustrations teach you the techniques you need to shoot outdoor portraits like a pro! $29.95 list, 8½x11, 128p, 60+ full-color photos, index, order no. 1632.

Professional Secrets for Photographing Children
2nd Edition
Douglas Allen Box

Covers every aspect of photographing children. Prepare children and parents for the shoot, select the right clothes capture a child's personality, and shoot storybook themes. $29.95 list, 8½x11, 128p, 80 full-color photos, index, order no. 1635.

Wedding Photojournalism
Andy Marcus

Learn the art of creating dramatic unposed wedding portraits. Working through the wedding from start to finish you'll learn where to be, what to look for and how to capture it on film. A hot technique for contemporary wedding albums! $29.95 list, 8½x11, 128p, b&w, over 50 photos, order no. 1656.

Studio Portrait Photography of Children and Babies, *2nd Edition*
Marilyn Sholin

Techniques for working with kids at every developmental stage, from infant to preschooler. Features: lighting, posing and much more! $29.95 list, 8½x11, 128p, 90 full-color photos, order no. 1657.

Professional Secrets of Wedding Photography
2nd Edition
Douglas Allen Box

Portraits are individually analyzed to teach you the art of professional wedding portraiture. Lighting diagrams, posing information and technical specs are included for every image. $29.95 list, 8½x11, 128p, 60 full-color photos, order no. 1658.

Photo Retouching with Adobe® Photoshop®
2nd Edition
Gwen Lute

Designed for photographers, this manual teaches every phase of the process, from scanning to final output. Learn to restore damaged photos, correct imperfections, create realistic composite images and correct for dazzling color. $29.95 list, 8½x11, 120p, 60+ photos, order no. 1660.

Storytelling Wedding Photography

Barbara Box

Barbara and her husband shoot as a team at weddings. Here, she shows you how to create outstanding candids (which are her specialty), and combine them with formal portraits (her husband's specialty) to create a unique wedding album. $29.95 list, 8½x11, 128p, 60 b&w photos, order no. 1667.

Innovative Techniques for Wedding Photography

David Neil Arndt

Spice up your wedding photography (and attract new clients) with dozens of creative techniques from top-notch professional wedding photographers! $29.95 list, 8½x11, 120p, 60 photos, order no. 1684.

Infrared Wedding Photography

Patrick Rice, Barbara Rice & Travis Hill

Step-by-step techniques for adding the dreamy look of black & white infrared to your wedding portraiture. Capture the fantasy of the wedding with unique ethereal portraits your clients will love! $29.95 list, 8½x11, 128p, 60 images, order no. 1681.

Photographing Children in Black & White

Helen T. Boursier

Learn the techniques professionals use to capture classic portraits of children (of all ages) in black & white. Discover posing, shooting, lighting and marketing techniques for black & white portraiture in the studio or on location. $29.95 list, 8½x11, 128p, 100 photos, order no. 1676.

Corrective Lighting and Posing Techniques for Portrait Photographers

Jeff Smith

Learn to make every client look his or her best by using lighting and posing to conceal real or imagined flaws—from baldness, to acne, to figure flaws. $29.95 list, 8½x11, 120p, full color, 150 photos, order no. 1711.

Professional Secrets of Natural Light Portrait Photography

Douglas Allen Box

Learn to utilize natural light to create inexpensive and hassle-free portraiture. Beautifully illustrated with detailed instructions on equipment, setting selection and posing. $29.95 list, 8½x11, 128p, 80 full-color photos, order no. 1706.

Portrait Photographer's Handbook

Bill Hurter

Bill Hurter has compiled a step-by-step guide to portraiture that easily leads the reader through all phases of portrait photography. This book will be an asset to experienced photographers and beginners alike. $29.95 list, 8½x11, 128p, full color, 60 photos, order no. 1708.

Professional Marketing & Selling Techniques for Wedding Photographers

Jeff Hawkins and Kathleen Hawkins

Learn the business of successful wedding photography. Includes consultations, direct mail, print advertising, internet marketing and much more. $29.95 list, 8½x11, 128p, 80 photos, order no. 1712.

Traditional Photographic Effects with Adobe® Photoshop®

Michelle Perkins and Paul Grant

Use Photoshop to enhance your photos with handcoloring, vignettes, soft focus and much more. Every technique contains step-by-step instructions for easy learning. $29.95 list, 8½x11, 128p, 150 photos, order no. 1721.

Master Posing Guide for Portrait Photographers

J. D. Wacker

Learn the techniques you need to pose single portrait subjects, couples and groups for studio or location portraits. Includes techniques for photographing weddings, teams, children, special events and much more. $29.95 list, 8½x11, 128p, 80 photos, order no. 1722.

The Art of Color Infrared Photography

Steven H. Begleiter

Color infrared photography will open the doors to an entirely new and exciting photographic world. This exhaustive book shows readers how to previsualize the scene and get the results they want. $29.95 list, 8½x11, 128p, 80 full-color photos, order no. 1728.

High Impact Portrait Photography

Lori Brystan

Learn how to create the high-end, fashion-inspired portraits your clients will love. Features posing, alternative processing and much more. $29.95 list, 8½x11, 128p, 60 full-color photos, order no. 1725.

The Art of Bridal Portrait Photography

Marty Seefer

Learn to give every client your best and create timeless images that are sure to become family heirlooms. Seefer takes readers through every step of the bridal shoot, ensuring flawless results. $29.95 list, 8½x11, 128p, 70 full-color photos, order no. 1730.

Beginner's Guide to Adobe® Photoshop®

Michelle Perkins

Learn the skills you need to effectively make your images look their best, create original artwork or add unique effects to almost any image. All topics are presented in short, easy-to-digest sections that will boost confidence and ensure outstanding images. $29.95 list, 8½x11, 128p, 150 full-color photos, order no. 1732.

Professional Techniques for Digital Wedding Photography

Jeff Hawkins and Kathleen Hawkins

From selecting the right equipment to building an efficient digital workflow, this book teaches how to best make digital tools and marketing techniques work for you. $29.95 list, 8½x11, 128p, 80 full-color photos, order no. 1735.

Professional Digital Photography

Dave Montizambert

From monitor calibration, to color balancing to creating advanced artistic effects, this book provides photographers skilled in basic digital imaging with the techniques they need to take their photography to the next level. $29.95 list, 8½x11, 128p, 120 full-color photos, order no. 1739.

Group Portrait Photographer's Handbook

Bill Hurter

With images by the industry's top portrait photographers, this indispensible book offers timeless tips for composing, lighting and posing dynamic group portraits. $29.95 list, 8½x11, 128p, 120 full-color photos, order no. 1740.

Photo Salvage with Adobe® Photoshop®

Jack and Sue Drafahl

This indispensible book will teach you how to digitally restore faded images, correct exposure and color balance problems and processing errors, eliminate scratches and much, much more. $29.95 list, 8½x11, 128p, 200 full-color photos, order no. 1751.

The Best of Wedding Photography

Bill Hurter

Learn how the top wedding photographers in th industry transform special moments into lastin; romantic treasures with the posing, lighting album design and customer service pointers foun in this book. $29.95 list, 8½x11, 128p, 150 ful color photos, order no. 1747.

Professional Digital Portrait Photography

Jeff Smith

Digital portrait photography offers a number o advantages. Yet, because the learning curve is s steep, making the tradition to digital can b frustrating. Author Jeff Smith shows readers how to shoot, edit and retouch their images—whil avoiding common pitfalls. $29.95 list, 8½x11 128p, 100 full-color photos, order no. 1750.

More Photo Books Are Available

Contact us for a FREE catalog:

AMHERST MEDIA
PO BOX 586
AMHERST, NY 14226 USA